Famous Artists School

How to Draw and Paint Landscapes

Dong Kingman
Manhattan is his home, but the world is Dong Kingman's studio! Covering the globe from Scandinavia to China, he continuously creates colorful and exciting drawings and paintings for exhibitions and special assignments. He has won numerous awards including two Guggenheim Fellowships, and his work is prominent in collections of many major museums—the Metropolitan Museum of Art, the Museum of Modern Art, the Chicago Institute of Art, and others.

Doris Lee
Her canvases, alive with exciting shapes and colors and subtle humor, have established her as one of the most distinguished women painters in America. Her pictures have always been in demand from museums and collectors—and have received high praise from critics. Few artists have been able to combine fine art painting with illustration as successfully as Doris Lee.

Peter Helck
Accomplished as a painter, etcher, lithographer, and sculptor, Peter Helck has always been happiest when depicting landscapes, ancient automobiles and dramatic industrial scenes. A member of the National Academy of Design, Helck's pictures hang in the Metropolitan Museum of Art, the Carnegie Institute of Pittsburgh, and the Congressional Library. His fame as an artist is matched by his skill and dedication as a teacher.

Robert Fawcett
Because of his outstanding mastery of draftsmanship and his highly personal use of color, Robert Fawcett was called "the illustrator's illustrator" early in his successful career. His dazzling technical ability and meticulous skill grew out of total dedication and a determination to settle for nothing short of excellence.

Franklin McMahon
One of the most traveled artists of our time, Franklin McMahon has drawn on the site such various activities as the Ecumenical Council in Rome, children at play in Bangkok and a crowded airport in Bombay.

So successful has McMahon been that his unique drawings and paintings are in demand by top magazines, large corporations, and television. He was named "Artist of the Year" by the famed Artists Guild.

Learn to DRAW AND PAINT LANDSCAPES with the easy-to-follow methods of these FAMOUS ARTISTS!

The Famous Artists School series of books pools the rich talents and knowledge of a group of the most celebrated and successful artists in America. The group includes such artists as Norman Rockwell, Albert Dorne, Ben Stahl, Harold Von Schmidt, and Dong Kingman. The Famous Artists whose work and methods are demonstrated in this volume are shown at left.

The purpose of these books is to teach art to people like you—people who like to draw and paint, and who want to develop their talent and experience with exciting and rewarding results.

Contributing Editor
Frederick Drimmer

PUBLISHER'S NOTE
This new series of art instruction books was conceived as an introduction to the rich and detailed materials available in Famous Artists School Courses. These books, with their unique features, could not have been produced without the invaluable contribution of the General Editor, Howell Dodd. The Contributing Editors join me in expressing our deep appreciation for his imagination, his unflagging energy, and his dedication to this project.

Robert E. Livesey, *Publisher*

**Famous Artists
School**

STEP-BY-STEP METHOD

How to Draw and Paint Landscapes

Published by Cortina Learning International, Inc.,
Westport, CT 06880.

Distributed to the Book Trade by Barnes & Noble Books,
a Division of Harper & Row.

How to Draw and Paint Landscapes
Table of Contents

ISBN 0-8327-0902-6 ISBN 0-06-464070-1

Designed by Howard Munce

Composition by Typesetting at Wilton, Inc.

Printed in the United States of America
9 8 7 6 5 4 3 2 1

Your Practice Projects...*how they teach you*

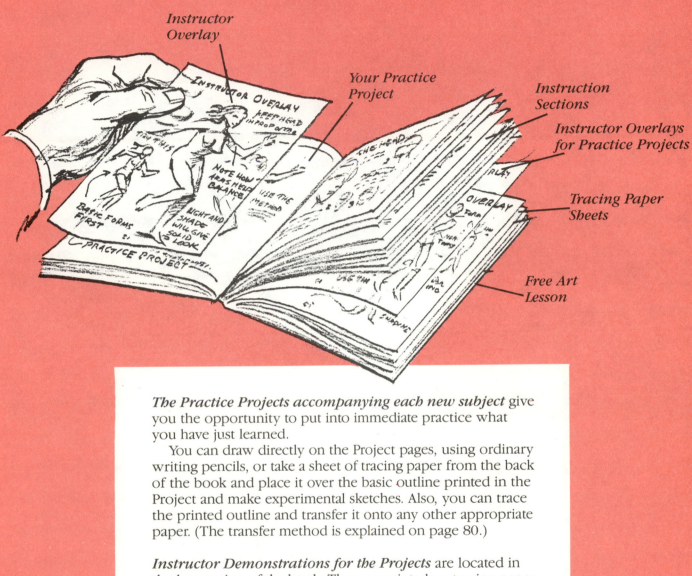

Instructor
Overlay

Your Practice
Project

Instruction
Sections

Instructor Overlays
for Practice Projects

Tracing Paper
Sheets

Free Art
Lesson

The Practice Projects accompanying each new subject give you the opportunity to put into immediate practice what you have just learned.

You can draw directly on the Project pages, using ordinary writing pencils, or take a sheet of tracing paper from the back of the book and place it over the basic outline printed in the Project and make experimental sketches. Also, you can trace the printed outline and transfer it onto any other appropriate paper. (The transfer method is explained on page 80.)

Instructor Demonstrations for the Projects are located in the last section of the book. They are printed on tracing paper overlays. You can remove them and place them either over your work or over white paper so you can study the corrections and suggestions.

Do not paint on Practice Project pages. This would damage the pages and spoil your book. If you wish to paint with watercolors you can obtain appropriate papers or pads at an art supply store. For oil paints you can get canvas, canvasboards or textured paper.

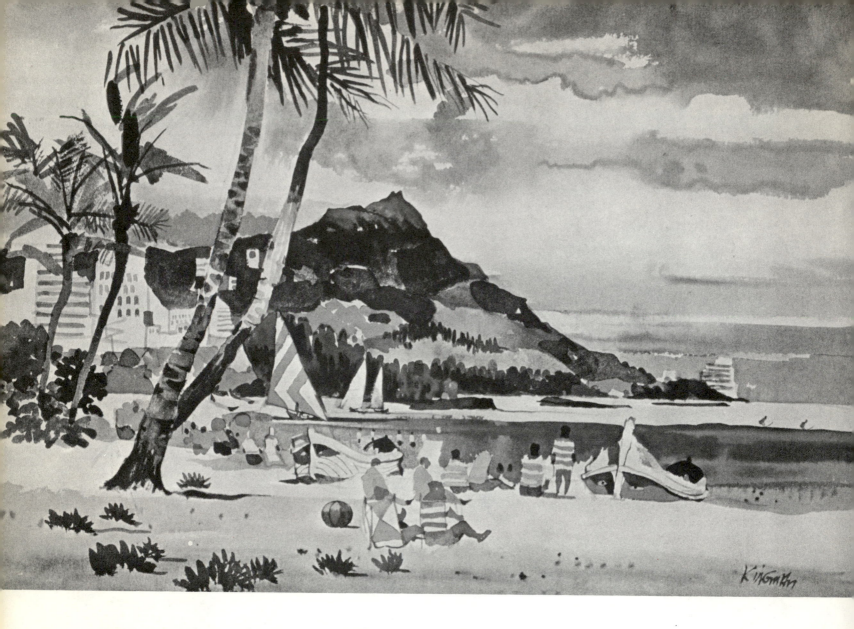

Four Artists Show You Their World:

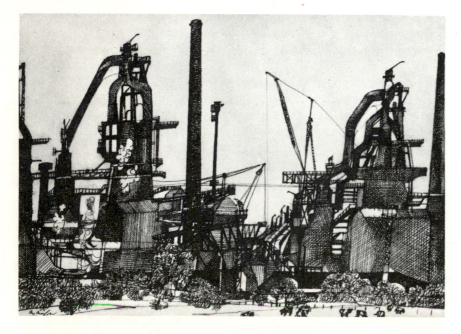

Dong Kingman's *Waikiki Beach, Looking Toward Diamond Head Mountain (above).*

Franklin McMahon depicts man-made structures *(left).*

Eric Blegvad drew this quaint London Street scene *(opposite page, top).*

Peter Helck captures the flavor of *Cotton Country* in a pencil sketch *(opposite page, bottom).*

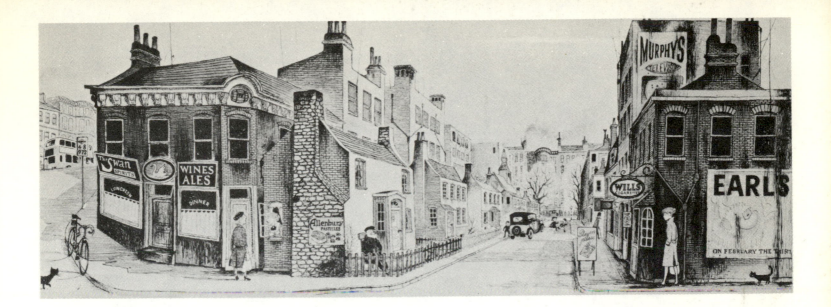

The World is Your Studio... *enjoy it!*

Nature has always been one of the artist's most inspiring teachers. Her dappled birches, somber pines—the strong stone faces of her cliffs, her turbulent waterfalls—her skies now black with angry clouds and now bright blue and smiling—here is a treasure house of images to enrich your imagination and fill your sketchbook.

Landscapes today are more than country scenes, of course. The massive giants of metal and concrete in whose wombs atomic power is conceived, the crisp lines of tall city buildings, the colorful neighborhoods of old towns—these too offer you a thousand exciting landscape subjects.

In these pages we introduce you to the techniques of drawing and painting landscapes, explained by some of America's most famous artists. You'll be thrilled to discover how much richer the world is than you had imagined, and you will see it with new eyes and with new happiness in your heart.

Working Tools

Pencils.
Ordinary writing pencils are fine for your Practice Project drawings. They come in grades ranging from soft to medium and hard leads. The soft pencils give you broader, darker lines and tones. Pencils used by professional artists come in leads ranging from 6B (very soft) to 9H (very hard).

How to sharpen pencils.
A regular pencil sharpener gives a sharp, even point. You can also sharpen your pencil with a single-edge razor blade and finish by shaping the point on a sandpaper pad or any fine grain sandpaper. For a wide, chisel-like point rub the point on the sandpaper without rolling it.

Erasing.
A medium soft eraser such as a pink pearl or the eraser on the end of a writing pencil is good for most erasures. Another useful type is a kneaded eraser which can be shaped to a point by squeezing it between your fingertips.

Charcoal.
This wonderfully responsive medium comes in three forms. There is the natural charred stick commonly called "vine charcoal." Then there are two synthetic forms. One is a pencil and the other a chalk about 3 inches long. All three forms come in varied degrees of softness (blackness). Natural charcoal is the most subtle and it erases most easily, using a kneaded eraser. The pencil kind is the least brittle and cleanest to handle.

Hold your pencil any way you find comfortable. The writing grip is a good position for carefully controlled lines and details.

The under-the-palm grip is good for working larger or more freely as when sketching outlines or shading.

Papers and Pads. *Drawing papers have different surfaces*—slick, average or rough (artists refer to the latter as having "tooth"). The Practice Projects are planned so you can draw directly on them. You will also find sheets of transparent tracing paper at the back of the book. For additional practice sketching, typewriter paper is good. A pad of drawing paper or common newsprint can be purchased at an art supply store where you can also get white and tinted charcoal paper. Another good type of practice paper is a roll of commercial white wrapping paper (but be sure it is not the kind with a wax surface).

Easel or Drawing Board. *Fasten your paper with tape*, thumbtacks or push pins to any light, firm board. Put a smooth piece of cardboard or several thicknesses of paper under your top sheet so rough or uneven spots on the board won't interfere with your drawing. An easel is fine to support the board but you can prop it in your lap and either hold it with your outstretched arm or rest it against any firm object. Another good method is to prop the board on the seat of a straightbacked chair. The seat then makes a good place to hold pencils and erasers.

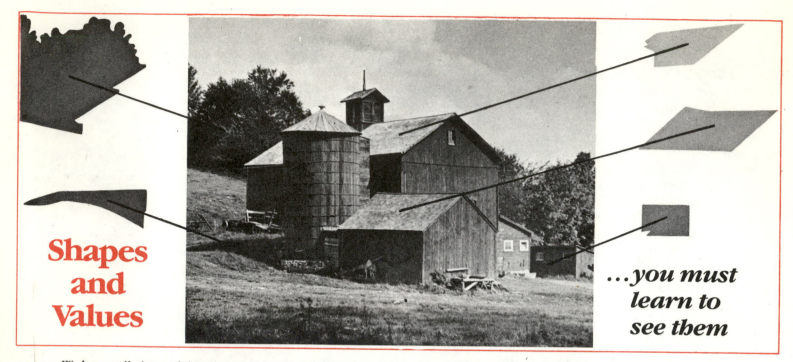

Shapes and Values

...you must learn to see them

We have pulled out of this photo just a few shapes to demonstrate the *part they play in seeing.* The trees, the roofs and side walls of the building, the shadow cast by the silo on the ground—all these are *shapes to our eye*, and each has a definite value.

Pictures painted on a flat surface are made up of carefully arranged shapes. Each of these shapes has a definite value. *Value simply means the lightness or darkness of a shape.* You must train your eye to see these shapes and values.

The simplest shapes to recognize are the silhouettes of whole objects, such as trees or roof tops. You must also train your eyes to see and recognize the shapes and values of light and shadow that make up objects. By putting these shapes down on paper or canvas you can create the illusion that the objects you are depicting are solid and three-dimensional.

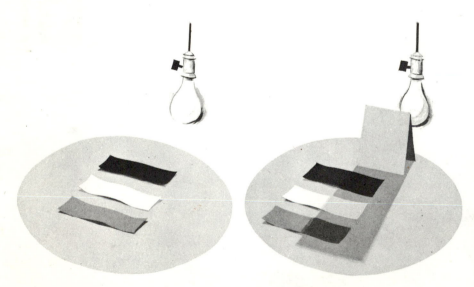

Here are three strips of paper, each a different *value*—white, gray, and black. When an object blocks out the light, all three strips are darker in the shadow. The relationship stays the same—that is, the shadow on the white strip is lighter than it is on the gray one, which, in turn, is lighter than the shadow on the dark strip.

This photograph is a good example of the principle demonstrated at the left.

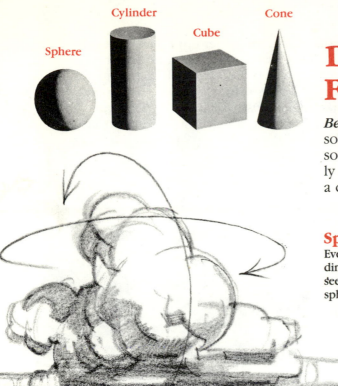

Drawing the Four Basic Forms

Below we show a simple way to draw forms so they look solid and three-dimensional. The form is first "drawn through" so it appears to exist in space; the details are put in last. Broadly speaking, all objects can be reduced to a sphere, a cylinder, a cube, a cone—or some combination of these basic forms.

Sphere

Even clouds have three dimensions. Those you see here are modified spheres.

Cylinder

The tree stump is a cylinder. Some of the roots are irregular cylinders, others sections of cone.

Cone

The basic form of this tree is a cone. A center line locates the trunk. Shading or modeling makes the form look solid. Finally, draw in the irregular branches.

Cube

First, draw the main lines—which represent the floor and wall planes of the house. Next, add the roof part, a section of a cube turned at an angle.

One-point Perspective

Parallel lines that go back into the distance all appear to draw closer together until they meet on the horizon or eye level and vanish from sight. We call this effect perspective with one vanishing point, or one-point perspective. Whether we are looking down a stretch of railroad track, a city street, or a country road, the effect is the same. The receding horizontal lines seem to converge. Keeping this effect in mind when you draw will help you give your pictures a sense of depth. All of the rules of perspective are based on one simple observation: the further an object or part of an object is from your eyes, the smaller it appears.

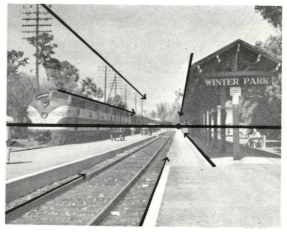

In this photograph the tracks, platform roof (and its shadow), train, and line of telephone poles are all actually parallel to each other. If we follow each line back into the distance they all appear to converge toward one vanishing point on the horizon.

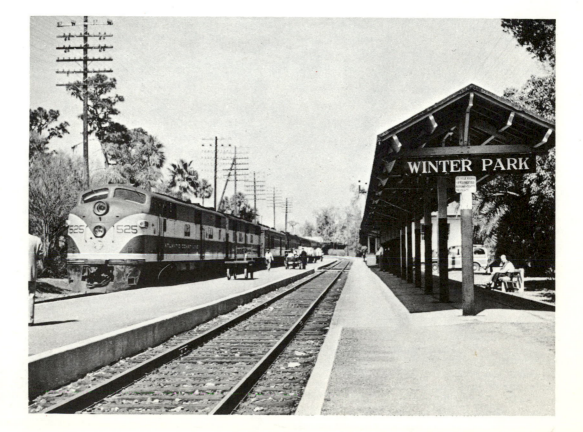

Two-point Perspective

You see things in two-point perspective when you look at them from an angle rather than straight on. Suppose you're looking at a house like the one below. You'll notice that lines that are actually parallel appear to come together as they go back into space. Those on the end of the house converge toward a vanishing point (VP) on the left, while those on the front converge toward a vanishing point on the right. Both vanishing points are on the horizon or eye level. A drawing you make from such an angle is called a two-point perspective drawing.

In drawing and painting landscapes you usually establish your converging lines and vanishing points "by eye." You seldom have to work them out mechanically.

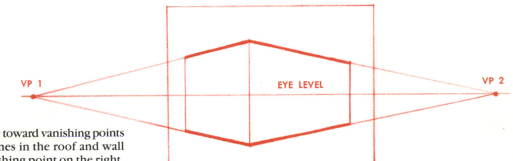

The lines of this house converge toward vanishing points on the horizon. The parallel lines in the roof and wall at the front all meet at the vanishing point on the right. This includes lines along the top and bottom of the windows, door, and steps. The parallel lines along the side of the house meet at the vanishing point at left.

In a two-point perspective drawing the two vanishing points are usually outside the picture area.

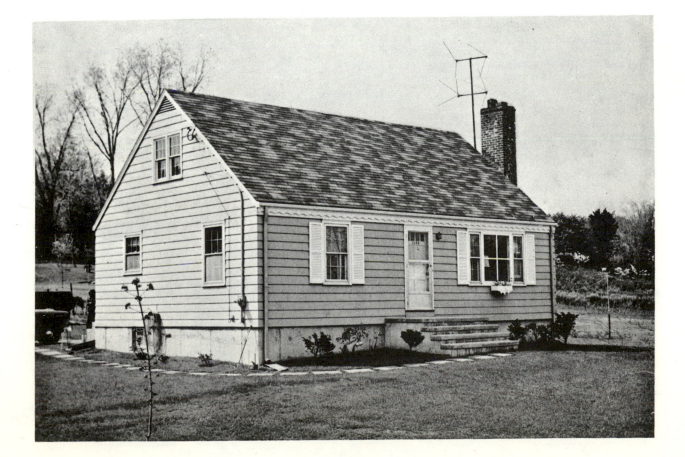

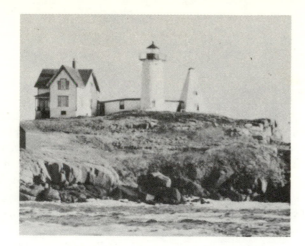

How to Draw Form
...step by step

A good basic rule to follow in drawing form is to work on the big shapes first and add the details last.

On this page we show you this procedure step by step with some simple drawings. Each step is based on one of the principles of form drawing we have stressed on the previous pages.

We'll use this landscape photo to demonstrate a practical method for drawing form, but note that the artist has not copied his subjects in photographic detail. He has rearranged forms—making the buildings more dominant than the land—whenever he felt it would help his picture.

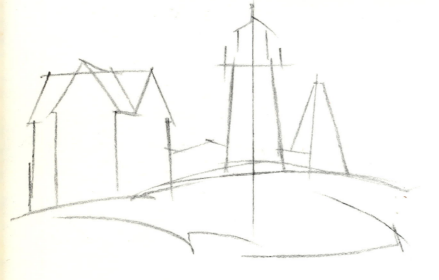

1 First, we sketch the general shapes of the *biggest forms*—the buildings and rocks. Compare the height of the buildings to be sure they are in correct proportion.

2 With the proportions established, we *construct each object* to create the *illusion of solid form*. Remember what you read about basic forms and perspective on the previous pages.

3 Now for details. Keep in mind the direction of light so your shadow areas will be consistent throughout the picture. Use shading and textures to show the solid form of the land.

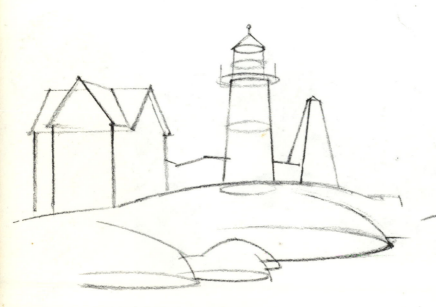

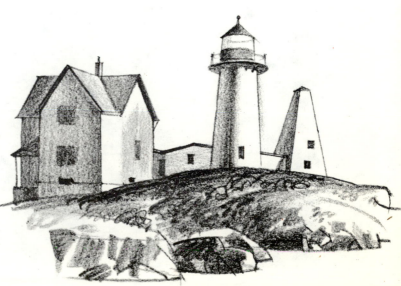

Practice Project
...making a pencil drawing

To prepare for your first Practice Project, study this demonstration carefully. It shows you a logical, orderly way to make a finished pencil drawing. On the next page you'll find a basic outline drawing of this scene. Draw directly on it, creating the same effects shown and described here. Use a "soft" pencil—either a No. 1 writing pencil or a 4B or 6B drawing pencil. Most of the strokes are to be done with your pencil sharpened to a chisel point, as explained on page 8.

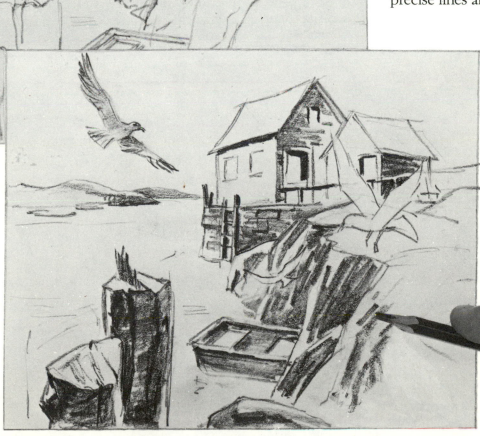

A word about holding your pencil

Hold your pencil any way you find comfortable for the effect you want to achieve. With the pencil held under the palm, as shown below, you can sketch freely and make bold strokes. The regular writing grip, shown on the following page, is good for carefully controlled, precise lines and details.

Working over the carefully planned outlines of the main shapes, as shown in the top drawing, you start putting in the tones or shading. Don't be concerned with details at this stage. Make the long chisel strokes to suggest the changes in direction of the planes of the rocks.

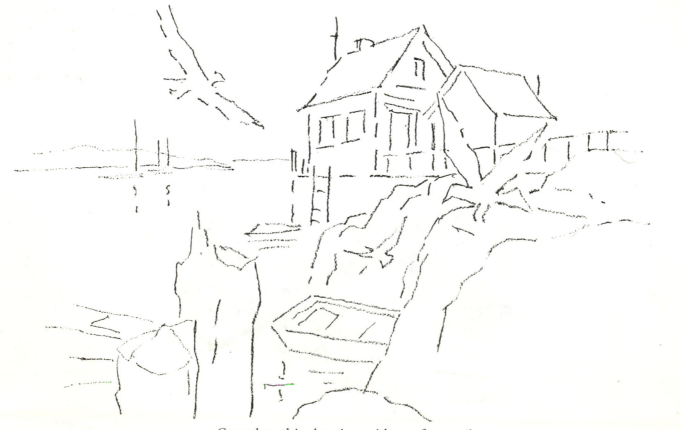

Avoid smudging the dark pencil strokes by resting your hand on a sheet of paper, as shown here.

The tones have now been built up and textures, such as the uneven shingles and board, have been suggested. The clouds are drawn with long horizontal strokes of the chisel-point pencil—4B or 6B. Use the darkest pencil you have for the rich black tones, applying heavier pressure for the darker strokes.

Practice Project

Complete this drawing with a soft pencil.

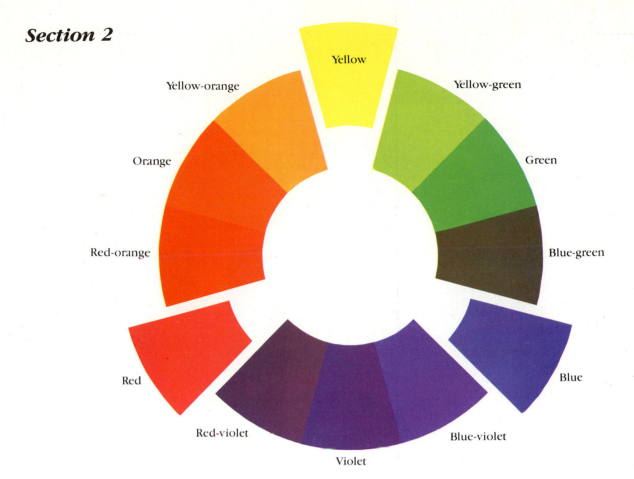

The Color Wheel

The circle of colors, commonly called a color wheel, has long been used in painters' studios and classrooms to show how hues are related in the world of art. We've sliced out of our color wheel the *primary colors*—red, blue, and yellow. You probably know that these three pure hues cannot be made by mixing, and also that all other colors are made from these three. When you mix any two of these three colors together you create *secondary colors*. You can make more colors by mixing the secondaries together or mixing them with the primaries.

Two other terms that will be useful when you're working with color are *analogous* and *complementary*. Analogous colors are those which are next to each other on the color wheel. Complementary colors are those that are directly opposite each other on the wheel. You'll find this page very helpful, so refer to it whenever you experiment with color.

How to mix secondary colors—green, orange, and violet

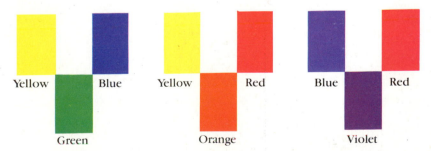

Mixing Intermediate Colors

On the previous page we showed you the color wheel and the three primary colors or hues—red, yellow, and blue. We also showed you that you can produce three secondary colors—green, violet, and orange—by mixing the primaries. The swatches of color on the right demonstrate how you can make six more colors—called *intermediate* colors—by mixing the secondary colors with the primaries.

The names of the intermediate colors—yellow-orange, red-orange, and so on—tell you the colors used to make them. To make the intermediates, as you see them here, you mix up equal quantities of the components. If you reduce the quantity of one of the components, then the hue of the larger component will predominate.

Practice mixing secondary and intermediate colors until you are thoroughly familiar with these hues and how to make them.

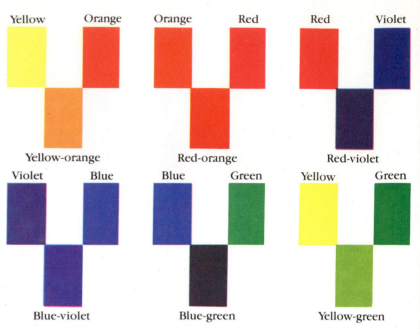

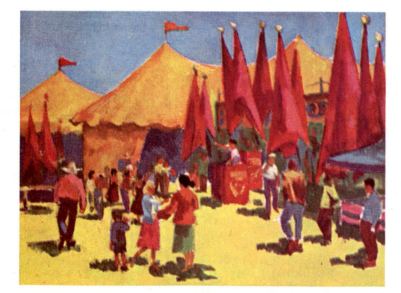

This sunny circus scene contains intense reds, yellows, and blues. The shadows, as well as the lights, contain pure, strong colors.

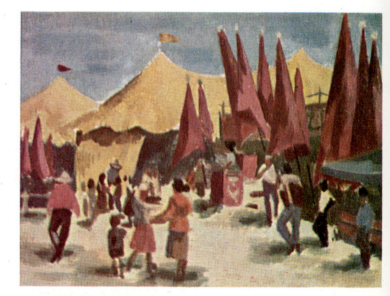

Here is the same picture painted in low intensity. Compare it to the one at the left. In the painting above, each color has been grayed.

Different color intensity can create different moods

Color intensity means the strength or purity of a color. A pure red of full intensity is redder than when it is mixed with some other color.

To reduce the intensity of a pure pigment you may add black, white or gray. This makes the color *weaker in intensity*. You can also reduce the intensity of any color by mixing it with its *complementary* (its opposite on the color wheel).

Bright, high-intensity colors help create a gay, light mood. Dark, low-intensity colors are better suited to a serious or somber mood.

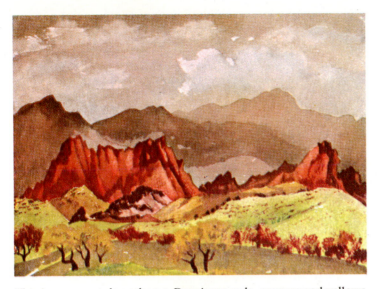

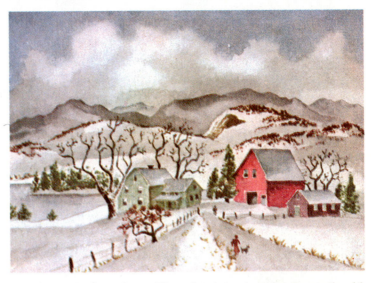

This is a warm color scheme. Dominant reds, oranges and yellows are appropriate for the sunny desert scene. Compare the warmth of the mountain and sky in this picture with the cool bluish-grays in the same areas of the painting at the right.

This is a cool color scheme. The colors in a winter landscape should reflect the temperature of the season. The artist here has captured the quality in cool hues of blue, green, and gray-blue. Even the red of the barn is cool.

Warm and cool colors

The colors on the left side of the color wheel, centering around orange, are called *warm*. Those on the right side, centering around blue, are *cool*. Colors halfway between these extremes, like yellow-green and red-violet, seem neither very warm nor cool. But if a green is fairly close to yellow, we sense it is warm compared with a green further toward blue on the wheel. Thus we speak of a "warm green" or a "cool green."

Almost any hue is warmed by adding yellow and cooled by adding blue.

Look for the warm and cool colors around you and learn to recognize them. As an artist, you must know the different reds, yellows, and blues and use them. Certain landscapes call for a warm color scheme, others a cool one, still others a mixture of both.

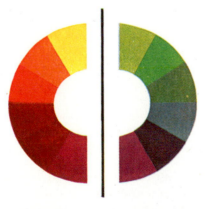

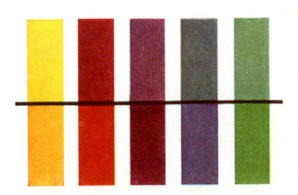

The hues in the left half of the color wheel are considered warm, those in the right half cool.

Each bar contains a warm and cool variation of the basic color. The upper half is cool, the lower half warm.

Watercolor palette

Brushes used for watercolor painting are described on page 34.

How to lay out your watercolor palette

There are many styles of watercolor palettes available but a simple white porcelain-coated butcher's tray makes an ideal mixing surface. Arrange your pigments like this—reading clockwise, they are:

> Cadmium yellow pale
> Raw sienna
> Cadmium red light
> Alizarin crimson
> Burnt sienna
> Raw umber
> Hooker's green
> Thalo green
> Thalo blue
> Cerulean blue
> Payne's gray
> Ivory black

Section 8

Watercolor painting

If you've never painted with watercolor you have an adventure ahead of you. It is ideal for making quick, on-the-spot color notes and sketches that can later be made into finished paintings. Its fluid, rapid-drying quality enables you to capture impressions that are fleeting in their beauty. Artists with facility in handling several mediums are warm in their praise of watercolor's flexibility.

Watercolor is clean and fresh. It's a medium to play with—to explore and discover with. You will have "happy accidents" with it that will be most satisfying. Sometimes your "quickies" will be the best of all—especially if you planned well in advance. No two experiences with watercolor are alike.

Watercolor is economical to use. The pigments are so intense in color that a little goes a long way when diluted with water. Also, the painting surfaces you normally use are less expensive than those required for oil paint.

We may give you the impression that transparent watercolor must only be used quickly. This is not intended. You can paint as deliberately as you like. But best results usually come from first planning your painting, sketching it in, and painting it—all in one continuous operation.

Some say watercolor is the most difficult of all mediums to master. This is no more true than to say that tennis is harder to learn than golf. To become proficient in any sport or any kind of painting, you must first master the tools of the trade. You must learn all the nuances, tricks, and techniques the scope of the medium allows. In the following pages, we will get you off to a good start.

Don't confuse *transparent watercolor* with *opaque watercolor* just because both are mixed with water. With *transparent*, the white paper—showing through—makes your light tones. With *opaque*, light tones and whites are made with white pigment. Your transparent watercolor palette contains no white.

First, we will familiarize you with the materials you use in transparent watercolor painting. Then we'll show you how a professional artist makes a painting.

Smooth

Medium

Rough

Reproduced actual size

This single, broad brush-stroke shows how three different paper textures take the pigment.

Watercolor paper

Speaking generally, watercolor papers come in three textures: smooth, medium and rough; and in three degrees or thickness of weight: thin, medium and thick.

The thicker the paper, the less the surface will wrinkle when dry—except when "wet-mounted," which we explain below. To paint a large picture, use the heavy or thick type, because large-size thin paper buckles awkwardly when wet and dries with a wavy surface. For smaller pictures, the medium type is satisfactory. Use thin paper only for practice and the smallest of pictures.

The medium and thin papers may be wet-mounted to make them smooth when finished and dry—even with fairly large pictures. To mount paper this way, wet both sides thoroughly and lay it flat on a wet wooden drawing board—leaving an inch or more of board area showing around the wet paper. When the edges begin to wrinkle, press down with your hand and fasten all four edges to the board with "shipping tape." (This comes in rolls with one side covered with water glue; it is used to seal packages for shipping.) When your painting is finished and dry, trim it around the edges with a razor blade to free it from the board. No need to wet-mount the heavier papers. Dry-mounting is sufficient. This is easy. Simply fasten your paper to the board with thumbtacks or masking tape all around the edges.

Watercolor pad. Inexpensive and practical for outdoors and in. Let painting dry, then peel off, as shown.

One way to dry-mount your paper—thumbtack it down around the edges to your drawing board.

Another dry-mount method. The edges of the paper are secured to the drawing board with masking tape.

Close-up technique of fastening edges of the paper to the drawing board with shipping tape.

21

How to Paint a Watercolor Dong Kingman

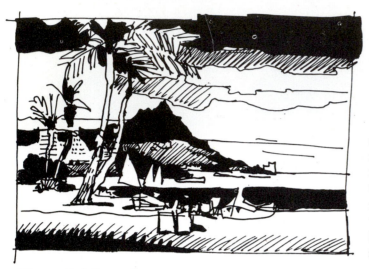

Rough sketch

Kingman sketches everywhere he goes. Some of these sketches become the inspiration for paintings he makes later in his studio. Before painting, he makes preliminary drawings like this pen and ink sketch. The decisions made at this stage are most important. Kingman makes many such sketches until he is satisfied that the composition and light and dark pattern are just right.

The very fact that watercolor is such a versatile and flexible medium means that there is no single *right* way to use it in painting a landscape, or any other kind of picture. Every artist who works with watercolor sooner or later finds a way of handling it that suits his tastes and requirements.

This demonstration was done for the Famous Artists School by Dong Kingman, internationally known artist and landscape painter, who ranges over the whole world in search of colorful subject matter. His favorite medium for interpreting the look and feel of the far-flung landscapes that catch his eye is watercolor. However, he is emphatic in pointing out that it is not the material or technique you work with that matters most. "I feel," he says, "that controlling the medium is secondary. How you express yourself and what is behind your thoughts is far more important."

The demonstration on these pages shows how Kingman develops a landscape from rough sketch to finished painting. The subject is Waikiki Beach, looking toward Diamond Head, in Hawaii. What first attracted him to this scene was the large, almost silhouetted shape of the mountain against the early morning sky.

Study the methods of this artist and adapt them to *your* subjects.

Starting the watercolor

Keeping his drawings before him, Kingman lightly sketched in the major areas and lines for the picture. Then, using a large brush (see page 34), he painted some big pieces of color. Note the variety of color he found on the mountain —red, grays, browns, greens and yellows. Using the wet-in-wet technique (see page 23), he painted the water an intense blue. With various grayed greens he painted the trees.

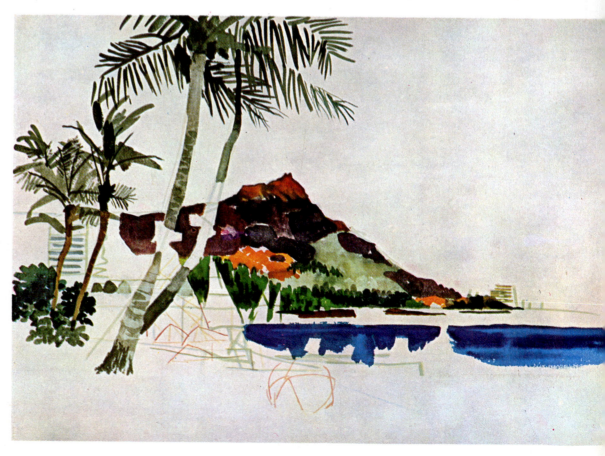

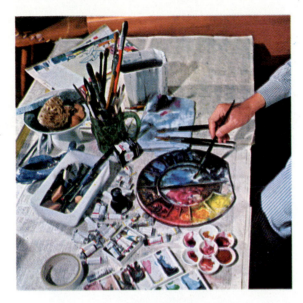

Dong Kingman's worktable

This close-up shows Kingman's painting equipment just as he uses it every day—a casual, comfortable arrangement. His round plastic palette has small outer compartments for his paints and large sections in the center for mixing.

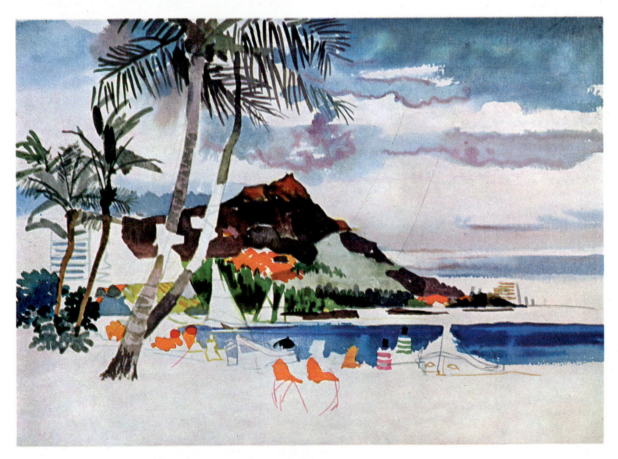

Painting in the sky—using wet-in-wet technique

Above, the artist used a broad brush to wet the large sky area with clear water, leaving the areas dry where the white clouds would be. He was careful not to run the water over the edge of the mountain. Then into this wetness he painted the grays and blues, working across the paper from left to right. Kingman painted the sky after he worked on the mountain because he wanted it to harmonize with and set off the colors of Diamond Head. After the sky was completed, the small accents of yellow and red were placed on the figures in the foreground.

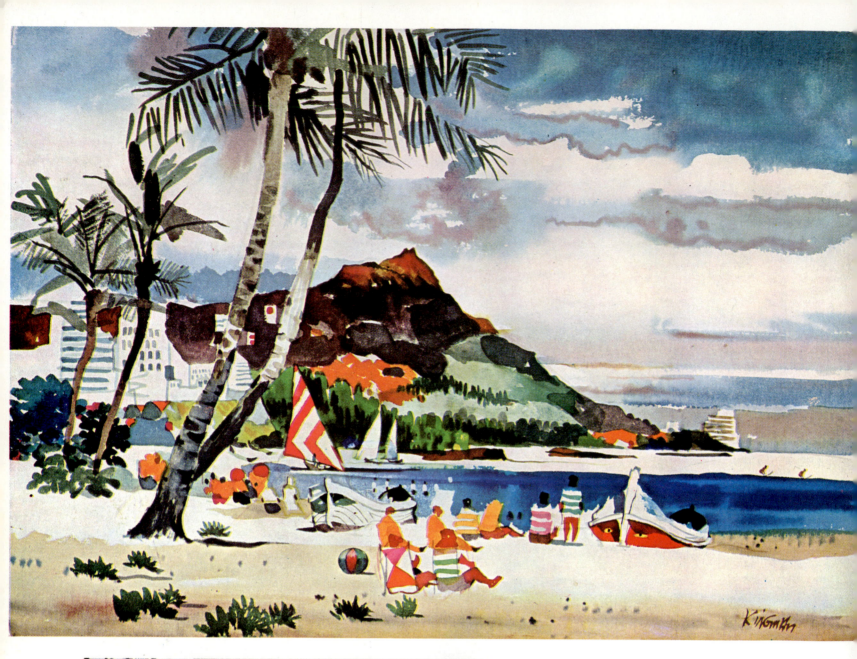

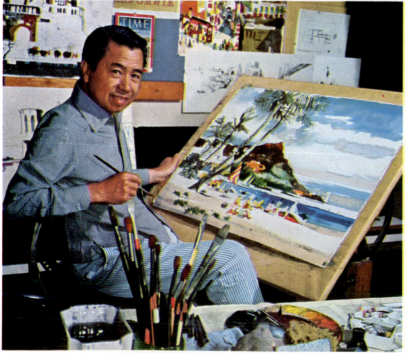

Finishing the painting

Finishing a watercolor painting takes a lot of thought to make sure that the final details don't destroy the freshness of the early stages. The sailboats, the people, the boats pulled up on the beach, the background buildings, the plants in the extreme foreground all give the painting a nice finish, but notice that Kingman kept these details simple and spontaneous looking. The artist himself is shown at left in his New York studio, adding a finishing touch to the painting.

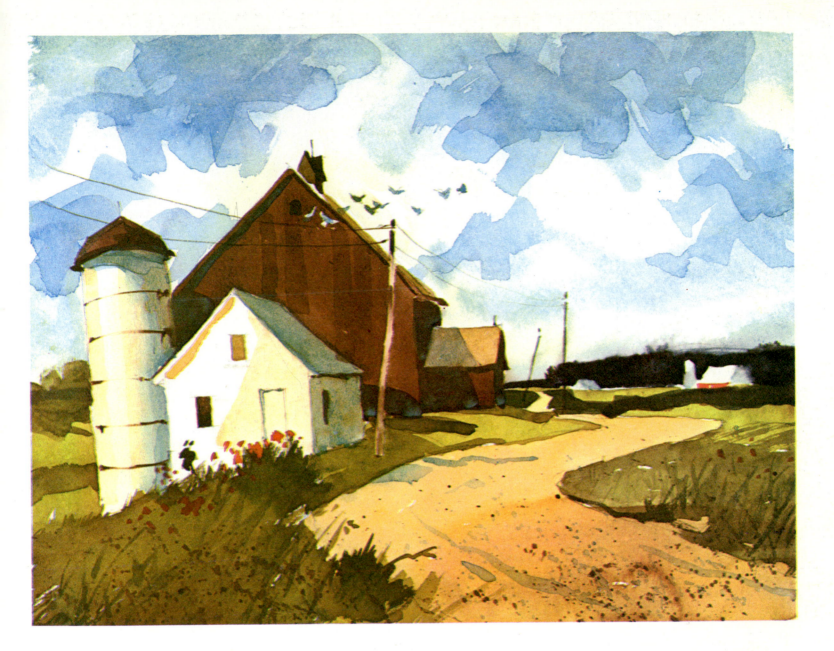

Practice Project...

Here's a chance to try out various watercolor effects. The picture may seem a bit complicated, but using the checklist below, you'll be surprised at the results you can get. On page 81, you'll find an outline drawing of this scene, printed on tracing paper, which you can transfer onto a sheet of watercolor paper as explained on page 80. You can also make a pencil drawing and afterwards compare it with the instructor's overlay on page 82.

Shapes and Values. Review page 10. Now look at the painting through squinted eyes (to cut out details) and you can see how the shapes fit together.

Color. Mix colors that approximate those in the painting. Keep in mind that watercolor washes look darker when wet than after they dry.

Techniques. Review pages 22 through 24 to see how Dong Kingman achieves his overall effect with carefully executed areas of color.

Spatter Effect. This is achieved by tapping the brush handle against your finger or a ruler so drops of paint will flip a spatter onto the painting (as on the road).

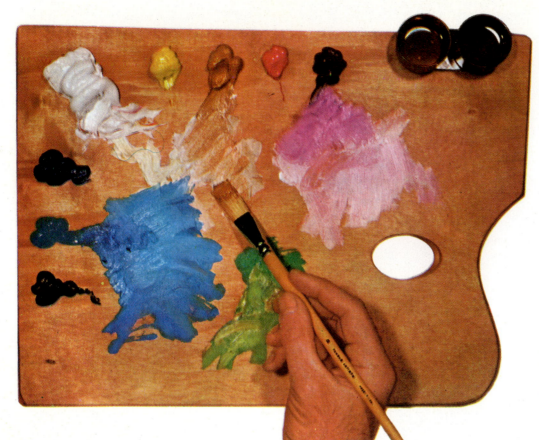

How to lay out your oil palette

Here's a typical setup for a palette. The warm colors are laid out along the top edge, the cool colors along the side. White is at the top left corner between the warm and cool colors. Although you can mix almost any color you need from the primaries red, yellow and blue, it saves time to have a wider assortment such as this. The colors shown here, reading clockwise, are:

Ivory black
Cerulean blue
Viridian green
Titanium white
Cadmium yellow pale
Yellow ochre
Cadmium red
Alizarin crimson

One of the palette cups clipped to the edge is for painting mediums—either commercially prepared or a mixture of your own. The other cup contains turpentine. (Many artists use an empty coffee can for this purpose.)

Section 3

How to Mix and Use Oil Colors

To become thoroughly familiar with your oil palette and gain confidence in using oil colors, start right in mixing pigments. Begin with two colors plus white. Each time you vary the amount of one of the pigments you create a new color. Just a few colors, plus black and white, can make limitless combinations.

The color combinations you'll make—such as the secondary and intermediate colors—are the same as those shown on pages 17, 18, and 19. With oils use white paint to lighten your colors instead of relying on the white of the paper as in watercolor. Also, generally apply the paint thickly. These same color-mixing principles apply to other paints, such as opaque watercolor (gouache) and polymer acrylics when used in a thick, opaque manner.

With oils you can paint on paper, wood, or other surfaces, but canvas is usual for finished pictures. Canvas board is useful too. Canvas-textured paper is suitable for practice. Bristle brushes are the most common painting tools. Sable and other soft-haired brushes are useful for smoother effects and details. You should also have a flexible palette knife to use in painting and mixing. A small one, called a painting knife, is popular with many artists, some of whom do some or all of their painting with this implement.

A good medium for thinning your paint is a mixture of one-third turpentine, one-third damar varnish, and one-third linseed oil. Commercially prepared mediums are also available. But at the start you can use your paints just as they come from the tube, thinning when necessary with a small amount of turpentine. Clean the mixing area of your palette after every working session, scraping off the paint and wiping it off with a turpentine-soaked rag.

Your palette can be a wooden one like the one shown, or of glass or any other stiff material. Another type has disposable tear-off sheets. As a starter, arrange the pigments as above, with extra white. Use your brush or palette knife to pick up small amounts of the paints you want, and blend them in the center with the brush or knife. Have rags handy to wipe your brushes, rinsing them with turpentine.

Now, on paper, experiment with mixing colors. Try the mixtures we demonstrated on pages 17, 18, and 19. Then try some of those on the facing page. As you can see, there can be many variations of a single color, such as green.

Cerulean blue
Cadmium yellow pale
Burnt umber, white

Cadmium orange
Cadmium yellow pale
Viridian

White
Cadmium yellow pale
Cadmium red light, viridian

Cerulean blue, white
Cadmium orange
Cadmium yellow medium

27

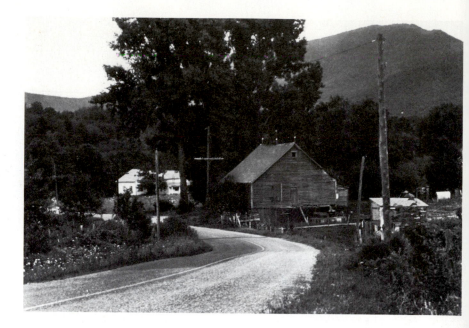

Here is a photograph we've chosen for our demonstration. It's very much the kind of scene you might come upon at any bend in a country road. There is a good deal of interesting picture material here—and that is precisely the painter's dilemma. Whenever you go to nature to paint, there is an overabundance of material. You must start to train your eye to select from the scene only those things which are important to your painting.

Painting a Landscape in Oil

On the next few pages we give you a demonstration of how to paint a landscape in oils. The basic principle is to work from generalities to details. Broadly speaking, you follow five basic steps in making any painting: (1) Placing the darks. (2) Adding the middle tones. (3) Painting in the lights. (4) Pulling the painting together. (5) Adding the finishing details.

Begin by studying your landscape in a number of pencil sketches, like those we show you here. These help you decide which feature to focus on, which to eliminate. Before you start to paint, ask yourself questions about colors and values. Here are a few: Where is the lightest light in the scene—the darkest dark? How light is the grass compared to the sky? How dark is the road compared to the trees? And so on.

As you'll see, you move from thin underpainting to thicker paint. This allows you to make changes in color and value easily. Start with the darkest tones, add the middle tones, then the lights. Build up your forms, following their contours with the brush. Paint broadly at first, saving details until last. Never think of yourself as working from top to bottom or from side to side. Work with the feeling that you are painting forms that exist in depth.

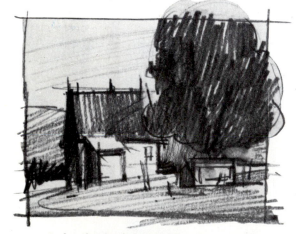

1 Before beginning to paint, make a number of rough sketches to find out what you want to include in the painting and how you plan to arrange it. In this first sketch we walked around to the right of the barn.

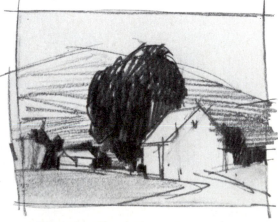

2 By moving around to the front of the barn, we get more of the feeling that attracted us to the subject. Though we've minimized the trees in our sketch, the composition is too scattered.

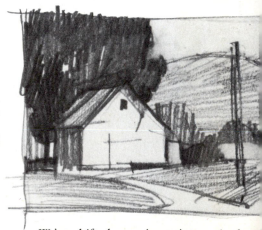

3 We've shifted our viewpoint so the barn is now the most important form. Working out composition problems and value pattern in preliminary sketches avoids trouble later on.

1. Toning the canvas

As a first step, most artists tone their canvas. The tone provides a middle value to relate color to and makes it eaiser to adjust values as we go along. Colors put down on a pure white surface seem too dark, creating a temptation to lighten them too much.

To tone your canvas, squeeze some oil color on your palette (we've used burnt umber). With a rag soaked in turpentine, rub a dab of color into your canvas. Keep the mixture mostly turpentine and rub the canvas almost dry.

With a small bristle brush and burnt umber, we rough in our major forms. We concentrate on the placement of forms, the large relationships —not on details.

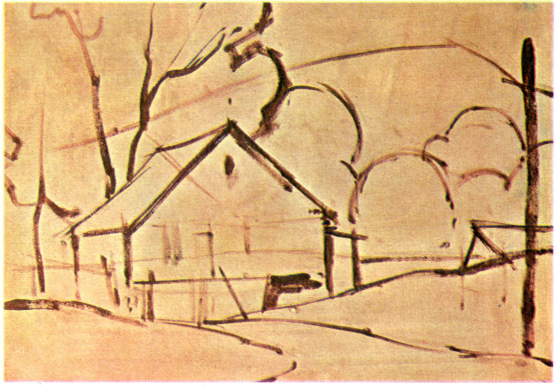

2. Laying in

Thin, dark colors are painted in the shadow areas with a large brush. Exact colors are not important yet, but they are suggested—deep green for foliage, umber for old barn siding, a thin wash of blue for the roof and the shadow in the road. When you're painting outdoors, these early stages should be done rather quickly, before the sun moves and the lighting changes radically. Keep your paint thin—almost a watercolor consistency for these first lay-ins.

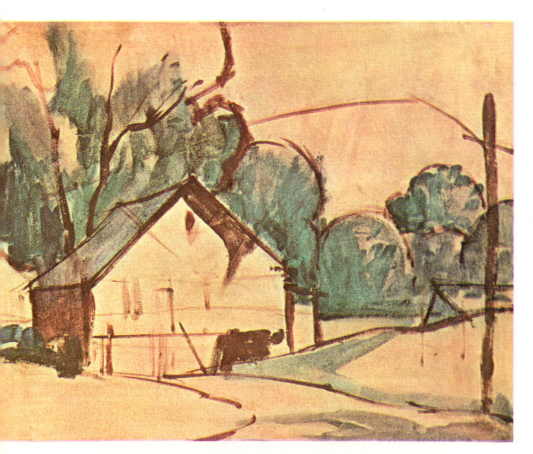

29

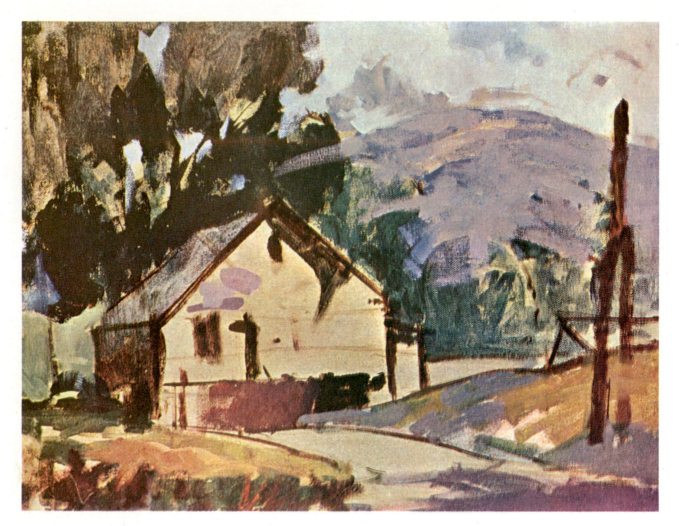

3. Laying in

We've continued to work on the darkest areas. Using a fairly large bristle brush, we've also begun to lay in the middle tones. One area can overlap another; shapes and values aren't final yet. It's enough to approximate them. We can make finer adjustments later.

As we lay in the sky, roughly indicating the shape of cloud and cloud shadow, we brush some sky color in the big tree, where the sky shows through. Some of the lighter color of the mountain is carried down into the trees. When they are further developed there'll be a feeling of "seeing through." At the right, the pole ran too parallel to the picture border, so we've begun to paint in a new pole.

This is an actual-size re-creation of the kind of strokes and thickness of paint used in the dark area under the barn. The size of the painting is 12 × 16 inches.

Though the paint is kept thin—almost like watercolor in consistency—even in these early stages the brushstrokes follow the contour of the landscape, as in this re-creation of the foreground grass area.

30

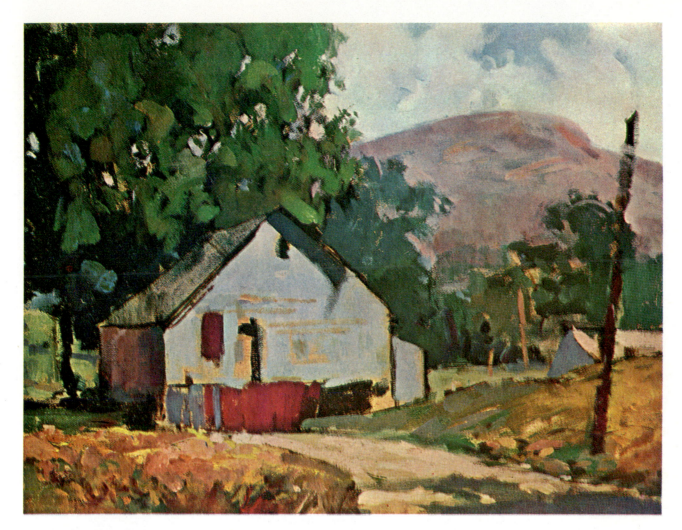

4. Final stages

All the canvas has been covered and we've gone on to pull the picture together. At this stage we apply the paint rather thickly over the thin underpainting. Note the tree mass at left, where we've overpainted with a warmer, lighter, thicker green and built up the feeling of form. Texture is important now. A cool gray was laid over the barn front allowing streaks of the warm underpainting to show through for variety. The mountain begins to take on its final form and color and we've eliminated the double image of the pole. We've also worked on the road and the foreground grass with color and textural variations.

As this swatch illustrates, in the final stages most of the underpainting has been covered with the thicker paint and the barn siding begins to take on a board-like texture.

Here is an actual-size re-creation of the grass in the later stages. The paint is not only thicker—the color is more varied and the direction of strokes more grasslike. Notice the variety of strokes, and how this creates a feeling of the haphazard way in which grass of this type grows.

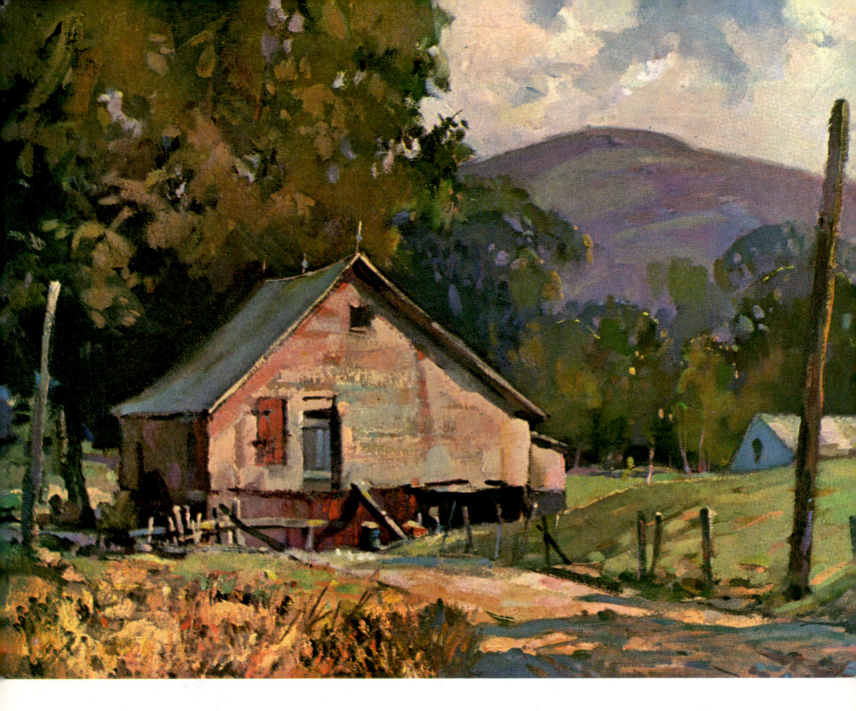

5. Adding the finishing details

Here is the finished painting. It shows a series of refinements. Values have been altered here and there, edges have been softened up or accented, crisp touches have been added to pull certain areas into focus, and details, such as the small blades of grass in the foreground, have been painted in. The smaller tools—the pointed and square-tipped sable brush and the small bristle brush—did good service here.

One big change is in the colors of the trees, which have been warmed up. The mountain shape and the clouds have also been altered. Before, they seemed to lean to the right and pull the eye out of the composition. Shifting the mountain's high point to the left and working on the sky a little corrected this. Other changes brought out the character of the barn, road, etc.

If you're new to painting, it may take you a while to do a landscape as finished as this. Practice is the answer—practice and constant experimentation. Remember the principles we've shown you. Work from dark to light, and leave details and minor adjustments till last. If you adopt a simple, commonsense approach like this, you'll soon be making pictures you can be proud of.

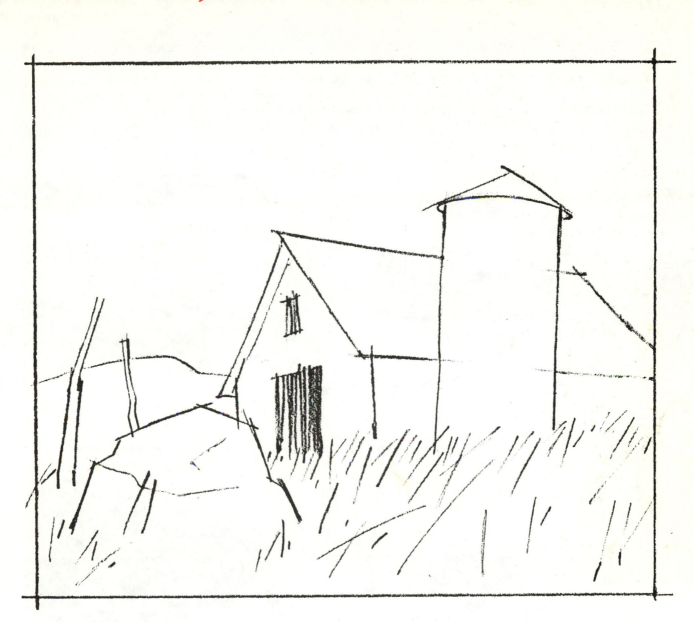

This project is planned so you can complete it with any of a number of different mediums. If you choose pencil or crayon, you can draw directly on this page. If you paint in oils or watercolors, you will find this same outline drawing printed on a sheet of tracing paper on page 83. You can transfer the lines onto appropriate paper for painting by the transfer method shown on page 80.

Review page 14 to see how the forms can be emphasized by strong light and shadow areas. Show the scene as it would look on a sunny day, with the light coming from the left side. Be sure to review the section that applies to the medium you plan to use—pencil, watercolor, or oils. After completing your pencil drawing, tear out the Instructor Overlay, page 84, for comparison and helpful suggestions.

Please Note: You can draw on this page with pencil, charcoal or pastel, but *do not paint on it*, as that would damage your book.

How to use color with water... methods and techniques

The tonal values in a watercolor are determined by the degree to which the white paper shows through the washes of paint. This, in turn, depends on the amount of water used in the brushes. A very wet brush will result in light tonal values. Less water will produce medium tones. Pure pigment with very little water, allowing none of the paper to show, will give the heaviest darks.

As you practice and learn you will be able to get many and varied effects by applying your brush filled with these different water and pigment mixtures. On this page are demonstrated a number of the more useful combinations you can get by using your brush from very wet to dry. A medium sized brush and a dark pigment were used in making these examples.

Watercolor brushes

No. 9 *round*

¾-inch *flat (single stroke)*

Your most useful brush will probably be the round shape. Rounds range in size from #4 to #14, the largest. The #9 is the most needed, but you might also want #4, #7, and #14 for a good range of sizes. Use large brushes for large areas, small ones for small areas, details, fine lines.

Three popular sizes of flat single-stroke brushes are the ½-inch, ¾-inch, and 1-inch. You might start painting with the middle size, then add others as needed.

Red sable brushes are the best. After use, clean them thoroughly in soap and warm water, but don't wash out all the soap. This keeps the hairs pliable.

Dry brush.

This stroke is made by drawing the brush—holding very little water and plenty of pigment—quickly across dry paper. Observe the flaky texture created.

Wet-in-wet.

A very wet brush, with pigment on very wet paper, gives us the above feathered-out blended-edge area.

Blended edge.

To make the edges of two wet colors blend, paint one quite wet, then place the other, less wet color so their edges touch. Color from the second stroke will blend into the first.

Scraped lines.

Before an area dries, you can scratch light lines through it with the butt end of your brush.

Using watercolor techniques

In this demonstration we show you how to apply the watercolor techniques explained on the previous page, plus some new ones. You can try your hand in doing your own version of this picture. No colors will be shown—we'll be talking about light and dark tones only. We want you to be free to use your imagination in planning the color scheme for your picture.

The first step (not shown) was to plan the picture in a few rough composition sketches. We selected the best one of these and sketched it lightly in pencil on the watercolor paper. If you must erase, do it gently, using a soft eraser. Rough erasures cut into the paper and make it take up paint unevenly.

Since in Step 1 you'll be painting a large area and will need freedom of movement, we suggest you do it standing up.

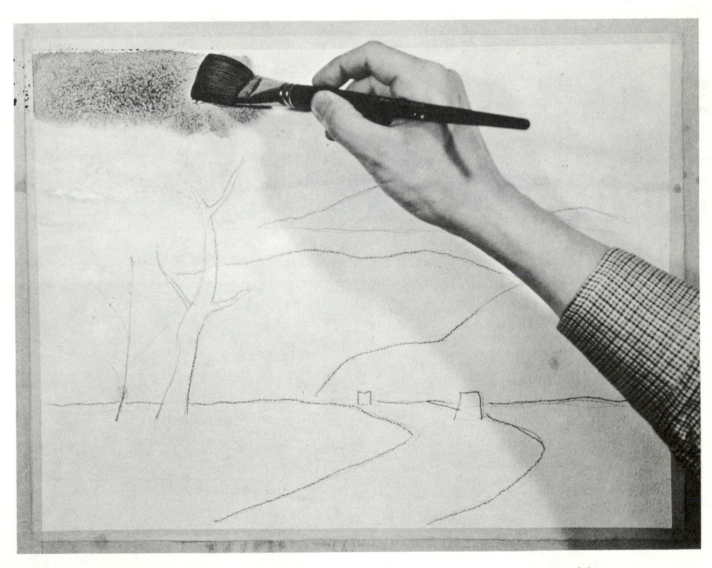

1 **Graded wash.** With a large flat brush, wet the sky part. Now thoroughly mix a lot of the sky color you want and test it on a piece of white scrap paper. If the color seems right, stroke it across and gradually down the area with your large brush filled with color. Add more water to the brush as you paint so the color grades from darker to very light behind the hills. Use a clean, moist brush to take out any excess water there.

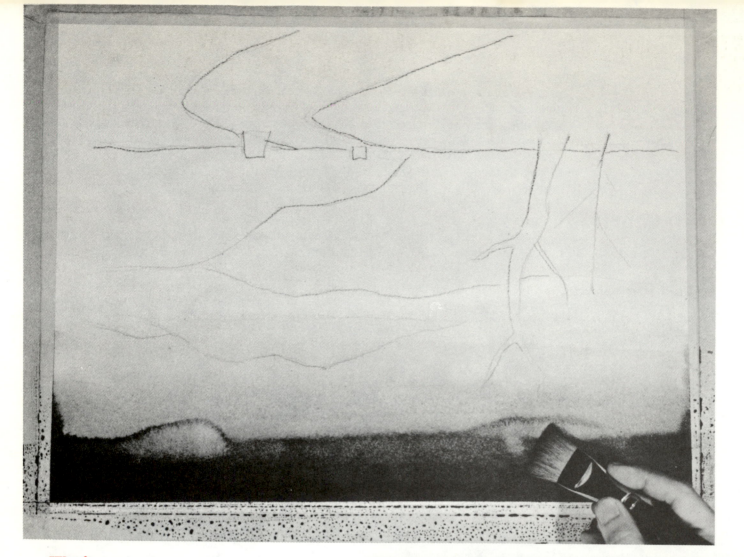

Wet-in-wet. When the sky has settled a few seconds,
2 turn your drawing board upside down and, using a large
brush, work much darker tones into the upper part of the
sky, as shown. This is to make the sky look interesting and
moody. It also enhances realism, since the sky looks light-
er toward the horizon. Drop on a little water here and
there in the dark area after it has settled, and let this dry
into rings or marks. This makes for more character than
if it were smooth and plain.

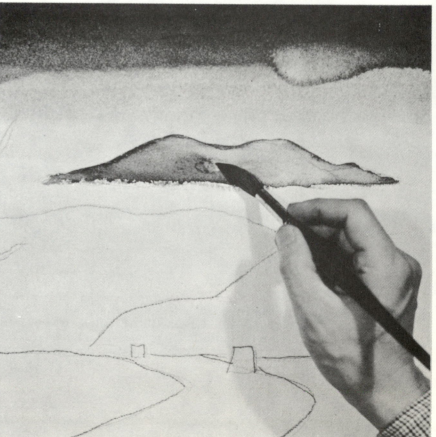

Edges—sharp and dry-brush. After the sky is
3 completely dry, paint the upper hill in the distance. If you
were to paint the hill while the sky area is still wet, some
of the color might bleed into the sky and keep the hill edges
from standing out sharp and clear against the soft back-
ground. Paint the hill freely with a medium-size round
brush, using a wet mixture. The lower edge disappears in
fog—so use a dry-brush technique to make it fade quickly
out of sight. Clean the brush and lift out color here and
there to make light areas for better form.

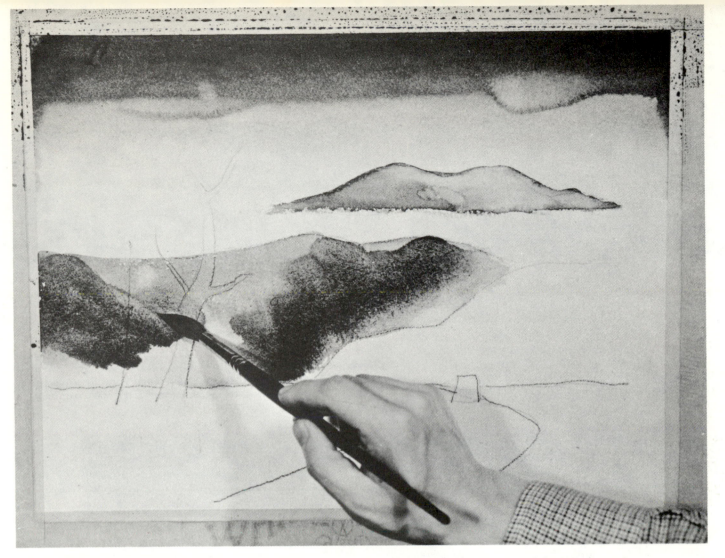

Dark-into-light. The left middle distance is painted into dry paper at the crest of the hill to give it a
sharp edge. Start at the top with a light wet wash, grade it downward, and then work the darker shadows
up into it, as demonstrated. Paint right over the sketch lines of the trees. These objects will later be painted
darker than the hill.

Water spots for texture. Let the paint on this hill settle a few seconds, then apply drops of clear
water here and there on the right slope and lower edge of the hill. Lift out the surplus water in these spots
so they look like light on one side of trees. This gives them form. Do the same quickly to several places on
the left hillside—and wait for the whole area to dry.

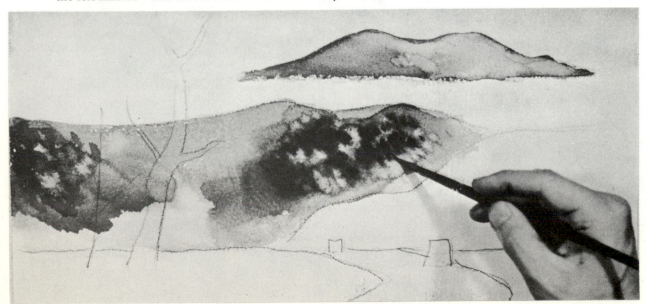

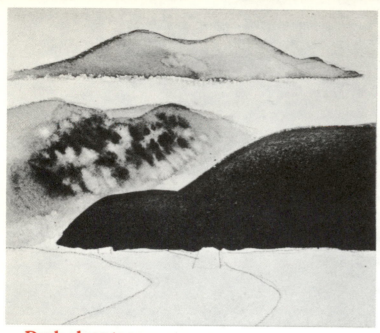

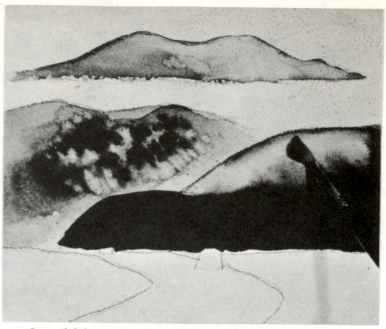

6 **Dark clear tone.** Paint the right middle-distance hill dark with a wet mixture and without wetting the paper first, either on the hill or around it. This hill should be dark to give depth to the picture and contrast with the misty look of the valley and fog area beyond.

7 **Scrubbing out the highlights.** When the dark wash has settled, but still is a little moist, clean your large round brush and squeeze out all the water. Then apply it along the upper areas, as shown, to lift out some of the dark paint and give form to the hill.

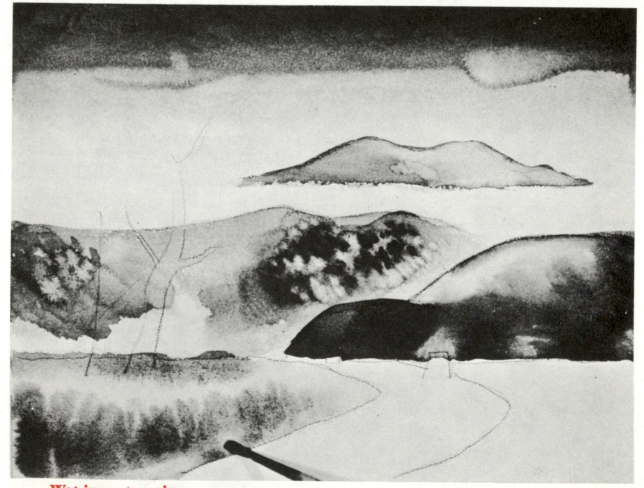

8 **Wet-in-wet again.** Wet the left foreground area—then grade a wet, slightly dark mixture down a little way beyond and around the base of the trees. Now do the same at the bottom, working up lighter into the central wetness. The larger, darker area in the immediate foreground will act as body for growing vegetation, which will be added a step or so later.

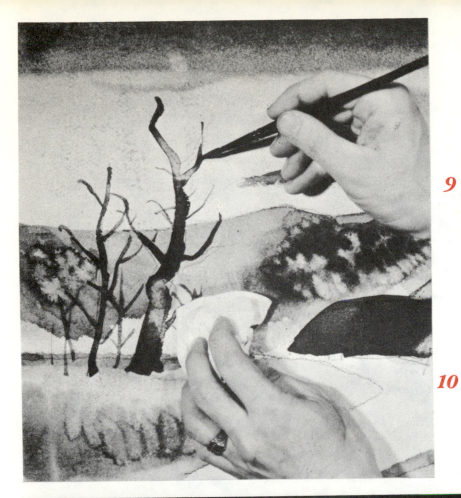

9 **Shapes and textures with brush and tissue.** The right foreground area of field and bushes has been painted wet-in-wet. The tree trunks were painted dark and fairly wet with a small round brush. Before they dry, some of the color must be lifted out to give them form and texture. Do this with brush cleaned and dried and by blotting with crumpled cleansing tissue. It is important to keep the direction of light in mind so that you may take out most of the color where the light strikes the tree. The smaller limbs and twigs are not put on the trunks just yet.

10 **Final details.** After the fog and road areas have been dry-brushed in with sweeping strokes, the automobile is painted. Using a small round brush, fairly dry, paint in the tree limbs and twigs, the grass in the foreground, and the birds. Notice that some color has been lifted out of the birds to give them a feeling of lightness. Try to make the rocks look hard and angular. As you near the end, work carefully and thoughtfully to give the watercolor that final polish which makes it sparkle.

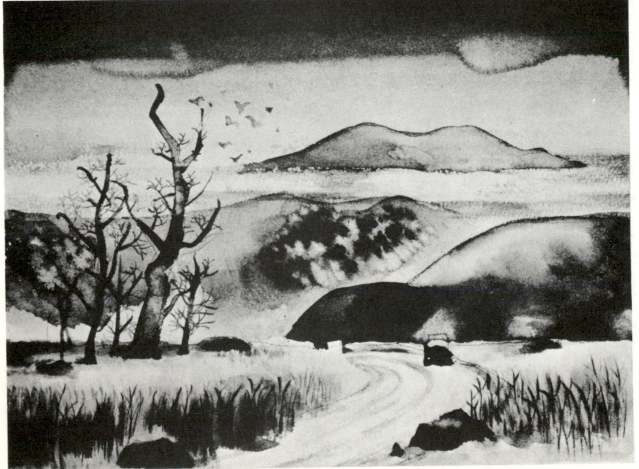

Practice Project...*tree*

Here is another project that is planned so you can complete it with any of several mediums. With pencil or crayon you can draw directly on this page. If you paint with oils or watercolor, use the outline drawing on page 85 and transfer it onto appropriate paper by the transfer method on page 80. This is a particularly good project to try out the techniques and methods shown in the watercolor demonstrations on pages 34 through 39—dry brush, wet-in-wet, etc.

Please Note: You can draw on this page, but *do not paint on it*, as that would damage your book.

Sharpening Your Eye to the Patterns Around You

Putting nature's patterns into a painting calls for a selective eye. Sort out the shapes you see, focus on the predominant patterns, and be aware of the underlying harmony in a scene. Once you "find" this natural order, use it in your pictures.

A hodgepodge of houses can have real character, an overall rectangular feeling. When these sharp shapes are backed up by the indistinct forms of trees with glints of light shining through the branches, a special tempo is created—the foundation for a lively, unified landscape. Practice seeing this way; become pattern conscious. You'll find patterns that are paintable all around you.

The overall pattern is what gives an artist's picture its own particular theme, its own tempo. An arrangement of shapes, similar but not exactly alike, can create rhythms of many kinds. When there is a variation or interplay of patterns, the painting's rhythms become richer. The large black-and-white illustrations below emphasize the patterns you can find and the rhythms and harmonies nature creates.

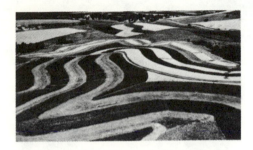

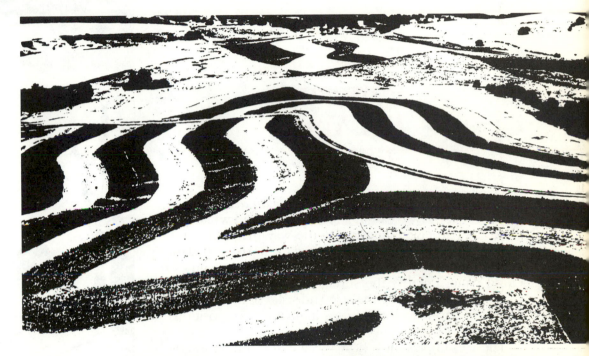

The pattern of these furrowed fields is one of rhythmic simplicity. The eye easily follows the repetition of the graceful curves; there is no interruption in the gentle flow. Patterns or designs like this are not always so obvious, but once you learn to recognize them you'll begin to see them all around you.

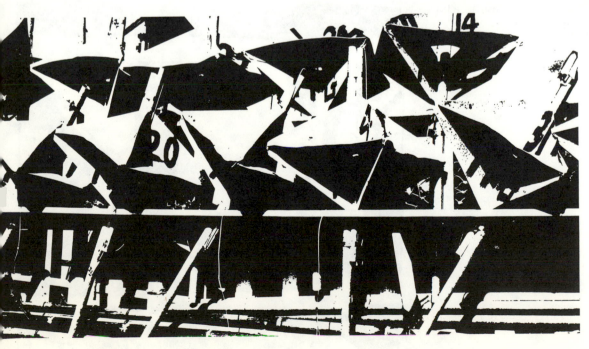

The geometrical shapes of the marker buoys make an interesting arrangement of light and dark triangles. The sharp patterns are in contrast to the horizontal lines of the platform and poles beneath.

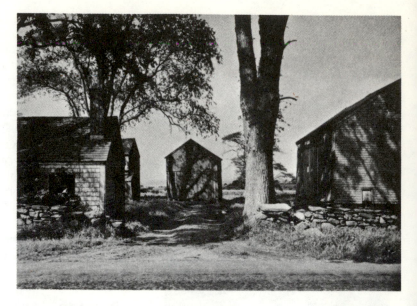

Designing Patterns For Your Picture

In this demonstration we concentrate on achieving as much variety as we can in a strong black-and-white pattern. Pay particular attention to the way that contrast—the playing of light areas against dark areas, and dark areas against light areas—has been used to create an exciting pattern across the surface of the picture. Notice that we tried changing the size and scale of the different buildings and placed the forms in a variety of positions in the picture space.

These examples show how, by careful planning and by rearranging your values, you can add visual drama to a subject you might find on any country road.

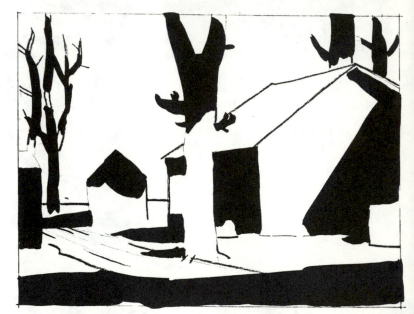

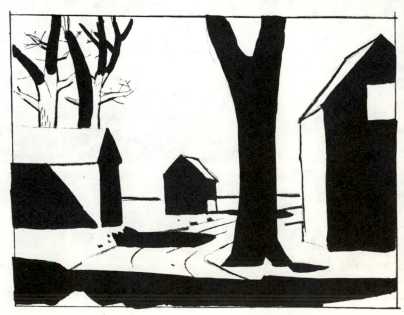

Keep the foreground light in this one.

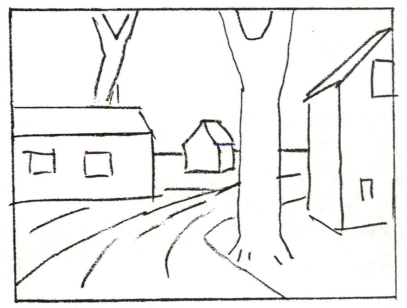

Try this one with the sky dark.

Practice Project...*designing patterns*

These two outlines are based on the photo on the facing page. Follow the instructions under each one. Draw with a soft pencil to get bold black-and-white shapes just as the artist did in the two compositions on the opposite page. Turn to the tracing paper overlay, page 86, to see an instructor's interpretation of these picture patterns.

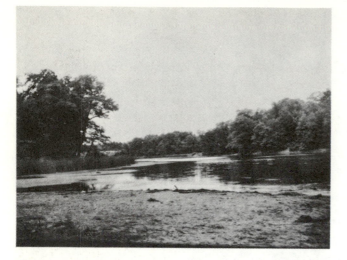

This photo looks less than exciting—how can we base a picture on it? First Fawcett sheared away some of the waste foreground and blank sky. The trees are interesting, so he enlarged them and played the rhythmic pattern of curves at the left against the massive tree forms at the right. Adding some clouds gives the sky character. Now a picture begins to emerge.

Finding the Key to Interest

The pictures on these two pages show you that a landscape which looks incredibly dull may actually contain key elements that can form the basis of a good picture.

Although you would normally choose an interesting, attractive subject for your painting, you may sometimes want to create a picture of a specific place that is important to you but doesn't have much obvious visual appeal. Actually, no setting is without the possibilities of interest. It doesn't matter how dull it seems—the material is there if you learn to see it.

These three rough, diagrammatic pictures done by Robert Fawcett, one of the founders of Famous Artists School, demonstrate the point. Sometimes the answer is to *exaggerate* forms, lines, patterns, or textures. Sometimes it is to *simplify* them.

Try all of these approaches. Design and organize, play one pattern against another.

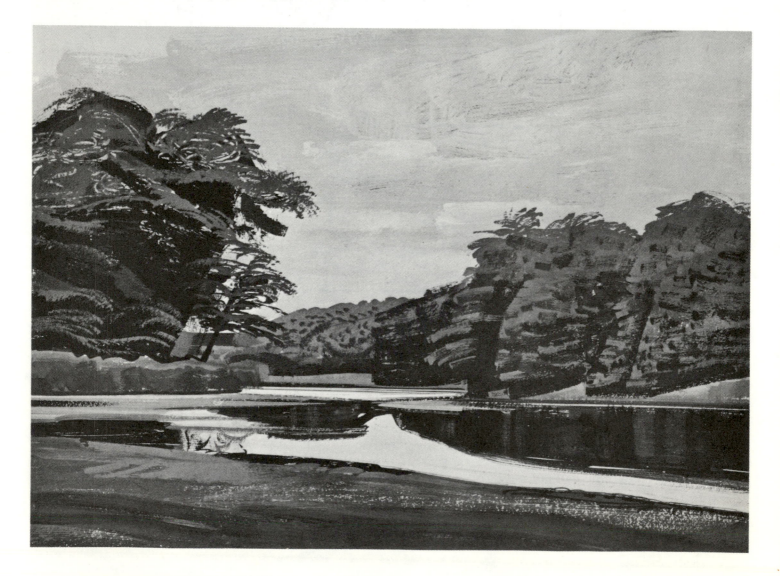

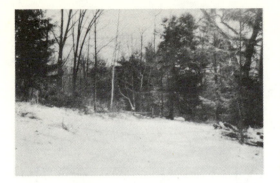

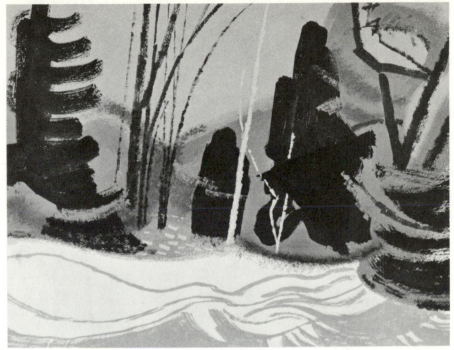

At first glance this photo seems hopeless—a confused maze of indistinct shapes. However, we can make out an interesting variety of forms at the left, the pine with its spreading branches, the graceful arching thin trees next to it, the white birches in the middle, the strong pattern of shapes at the right, and the shadows on the snow.

At the right Fawcett has picked these elements out of the confusion and played them against each other to form strong, interesting contrasts. In a more finished picture, he would make very sure the details didn't destroy these elements.

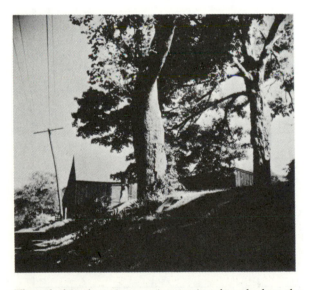

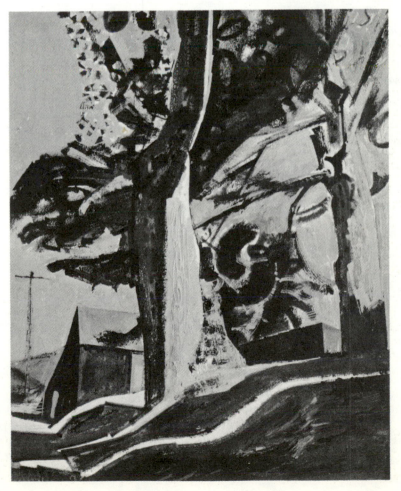

Though this photo is more interesting than the last, the composition is still somewhat haphazard. We must develop the underlying structure—emphasize the shapes, rhythms, and textures—if we are to paint a picture and not copy a photograph.

Before going to work Fawcett asked some questions: Can we see distinct shapes in the light and shadow areas on the trees? Isn't the telephone pole falling out of the picture? Are some areas of foliage solid, others delicately filigreed?

At the right you see the answers. The picture has been made vertical and the streaks of light curving on the bank have been made into a clear, exciting pattern. Branches and foliage are organized into designed areas of texture. Everything has been made more definite.

Practice Project...*value patterns*

The purpose of this project is to train your eye to create compositions composed of simple value shapes. Before starting, review page 10, where we discussed the importance of seeing the shapes and values that fit together to form a picture's basic value pattern.

All through this book we have emphasized that this value pattern is the key to picture composition. As you develop a picture you can add descriptive details and textures, but you must never lose sight of your basic value plan.

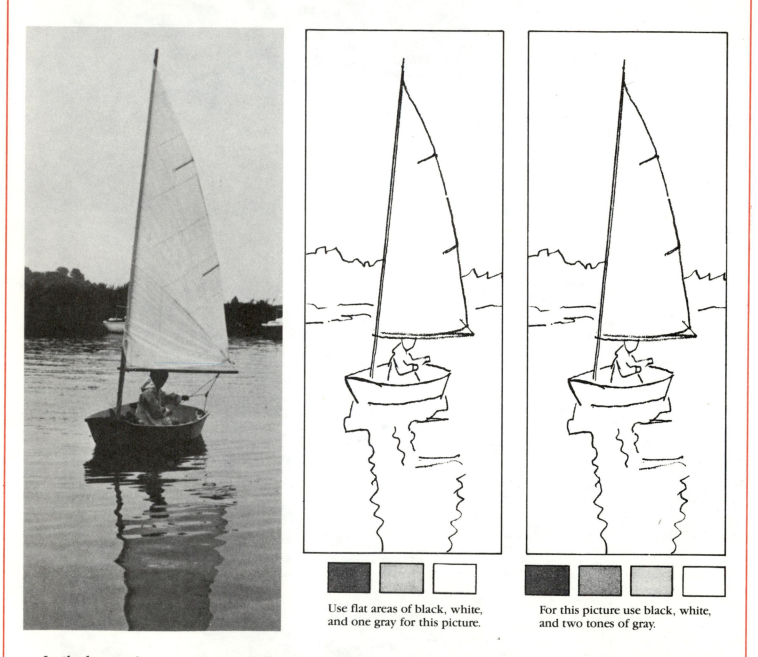

Use flat areas of black, white, and one gray for this picture.

For this picture use black, white, and two tones of gray.

In the boxes above, create two different value patterns based on this photograph. Use a soft pencil and carefully fill in the flat values. Shift the values if you wish—making the sail white against a gray sky.

Squint your eyes so you can more easily see the major shapes in the photograph. This helps eliminate distracting details. When you have finished, turn to page 87 and compare your work with the Instructor overlay.

Four Ways to Create Depth in Your Pictures

Nature plays tricks on our eyes when we look far into the distance. Objects grow smaller and dimmer, parallel lines seem to move closer together. Because these illusions are always associated with distance, you need to put them into your paintings when you want to create the appearance of depth.

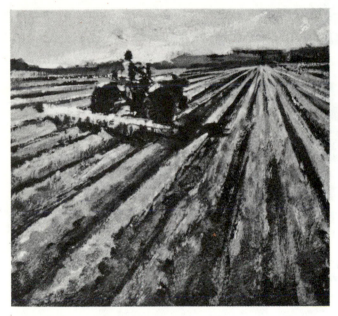

Converging lines

Parallel lines in nature, such as railroad tracks, the edges of a straight road and the furrows in a freshly plowed field appear to close in on each other as they move away from us, and to converge finally at the horizon. (We learned earlier that this effect is called one-point perspective.)

Diminishing size

A faraway object looks smaller than the same thing nearby, even though they are actually the same size. At left, the artist has used this illusion to put distance between three trees and give depth to his picture.

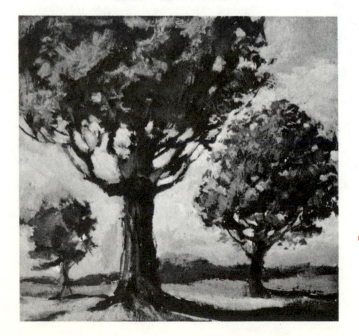

Overlapping shapes

When we see one object in front of another, we know that it is closer to us than the object it partly conceals. That's why the overlapping of shapes in a picture creates the illusion of depth.

Softening atmosphere

Objects you see in the distance not only look smaller, they are grayer, hazier, and less detailed than objects near you. They are blurred and softened by the atmosphere that is between them and your eyes. Use this and the other effects shown on these two pages to create the illusion that your picture exists in three dimensions.

How to Create Picture Depth with Advancing and Receding Colors

Have you noticed how some colors appear to come forward, while others seem to recede? You can use this knowledge either to stress or subdue the feeling of depth in your pictures.

Warm colors, like reds, oranges, and yellows, actually appear nearer to us than cool blues, greens, or violets, seen from the same distance.

In addition to becoming *cooler* with distance, colors also become *lighter* and *grayer*, or less intense, as we saw on the last page. This is due to the atmosphere between the object and our eyes. The use of these color changes to create the illusion of distance in a painting is called *aerial perspective*. The picture below demonstrates how this principle works in a painting. Although the earth in the plowed field is the same throughout, the foreground appears most intense in color. See how the color gradually becomes grayer, cooler, lighter, in the distance. The same principle has been used to create the illusion of great distance between the nearest and farthest hills and mountains.

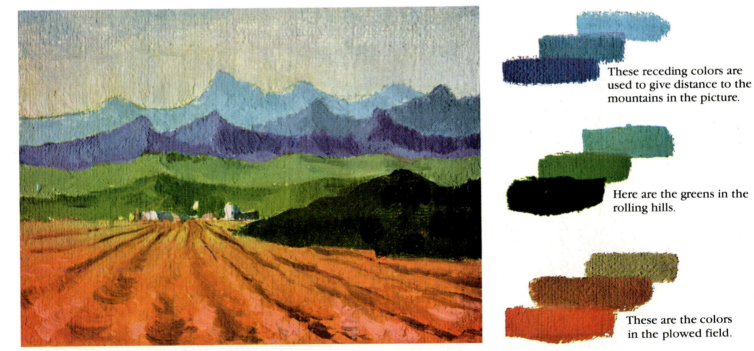

These receding colors are used to give distance to the mountains in the picture.

Here are the greens in the rolling hills.

These are the colors in the plowed field.

Note that the author has used color here to create depth, as well as applying the four methods shown on pages 47 and 48: converging lines, diminishing size, overlapping shapes and softening atmosphere.

How the Color of Light Affects Colors in a Painting

The color of light falling on objects has a strong influence on the way we see them and portray them in a painting. The color of everything is determined by three important factors:

1 *The local or intrinsic color of the object.* For example, the orange color of a tile, the green color of a leaf, etc. The local color of the cube at the left is red.

2 *The color of the direct light striking the object.* For example, the golden glow of a sunset or the blue light from the sky.

3 *The local color of any surface that is reflecting light upon the object.* For example, the yellow color of a house wall that reflects light upon a nearby object.

The influence of direct light on color

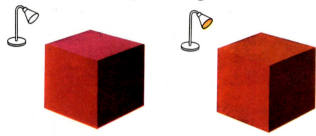

A neutral white light shows the true local color of the red cube. The top surface is lighter, due to the angle of the light.

A warm yellow light, such as sunlight, changes the pure red toward red-orange.

The influence of reflected light on color

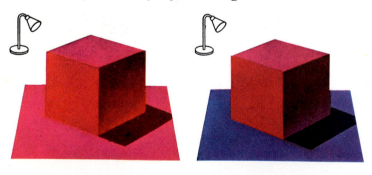

Here a white light illuminates these two cubes. Note that reflected light from the surfaces on which the cubes rest affects their color—intensifying the redness of the shadow side of the left cube and creating a violet effect on the shadow side of the cube on the blue surface.

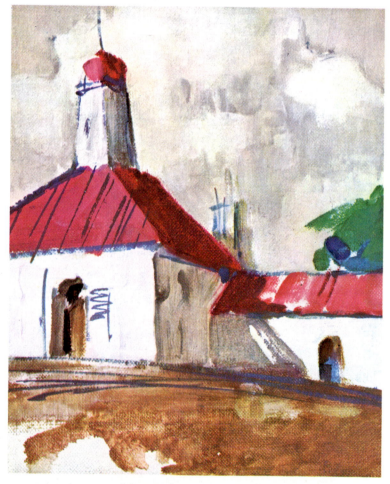

Light without "sunlight color"

The paintings on this and the facing page show two different ways of depicting a scene in sunlight. The one on this page achieves its effect by its strong pattern of light and shade and the distinct shadow cast on the building. No attempt has been made to relate the color to the light source—the sun—or to light reflected from the surroundings.

How to Put Sunlight in Your Color

The light areas of the clouds have been warmed with a bit of cadmium orange, the shadows cooled with ultramarine blue and alizarin crimson.

The roof in sunlight has been warmed by adding cadmium red light and a little lemon yellow to alizarin crimson.

Cerulean blue has been brushed into the shadow side of the roof to indicate the cool reflected light of the sky.

Here, cadmium orange has been added to the light side of the building to give it a strong feeling of warm sunlight. (Sunlight appears warmest in the morning and late afternoon.)

For the cooler shadow areas, cerulean blue and white were reduced in intensity with cadmium orange. The orange comes through stronger in some areas to suggest reflected light from the sunlit surroundings.

Venetian red and a little yellow ochre have been mixed with the burnt umber for a rich, warm color. (The choice of which warm and cool pigments to use depends on the effect you want.)

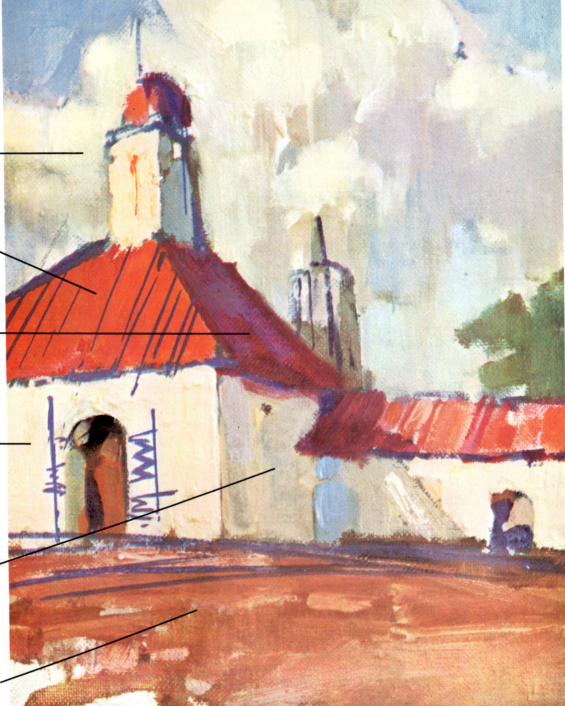

Light with "sunlight color"

In this painting we used the same distinct pattern of light and shade and cast shadow, but the color has been added in a more realistic way. It emphasizes the warm light of the sun and the cool influence of the sky.

How you use color will depend on the effect you want. If your intention is to relate it directly to nature, make use of the principle of warm and cool color shown above.

Make Your Landscape Elements Specific

Every tree has a shape of its own.

Before you begin a landscape, study the *specific character* of the scene. In painting, generalizations are dull and inaccurate—avoid them. Keep your eyes open and observe the interesting differences in landscape elements such as clouds, land, trees, streams, etc. Carefully note the exact character of a particular woodland or a mountain range. Don't start out with preconceived ideas of a landscape or you may paint a city park when your subject is a wild woodland scene.

A tree in a landscape, after all, is not just *a* tree. Every tree or other landscape element has its own *particular characteristics*. You must see these characteristics and draw them to create effective, convincing pictures.

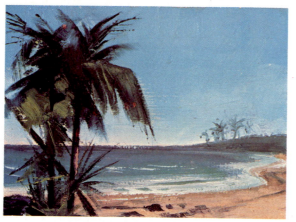

One palm tree is not another. Each coastline has its own character.

Some mountain forms are rolling and hilly.

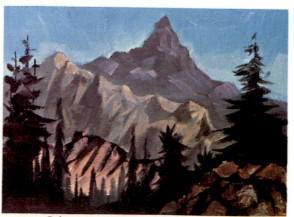

Others are jagged, with tall peaks.

52

The sky...
and how
it changes

This sunset has many indistinct high clouds that give interesting texture to the sky.

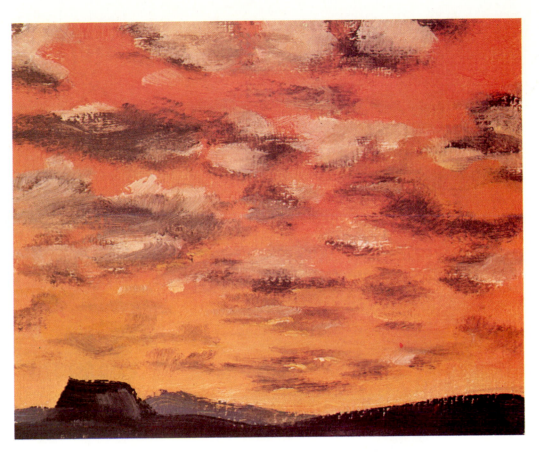

Nature is always changing, always different—and nowhere more than in the sky. Depending on its color and cloud shapes, the sky can look threatening, cheerful, or calm. In a picture the specific forms of clouds not only reveal the weather—they also offer you shapes and textures you can use to make your compositions more effective.

Pay particular attention to the clouds and sky and learn the way these landscape elements show the time and weather. Keep them consistent with other elements in a picture. Remember, the wind that blows clouds will also affect smoke, flags, and a boat's sails.

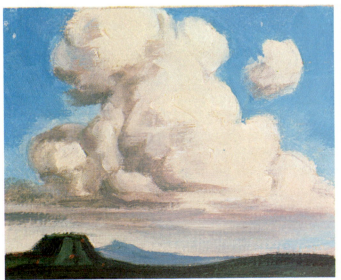

Mountainous cumulus clouds often precede a thunderstorm.

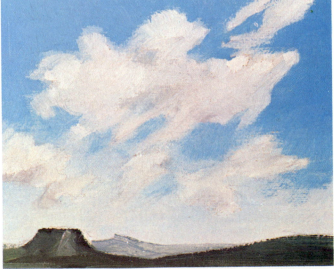

Light, fleecy forms that drift slowly make another interesting cloudscape.

Water too has infinite variety

Water is never just water—it is water in a particular place, at a particular time of day, under specific weather conditions. In a mountain lake water is calm, in a swift stream it rushes and bubbles; in bad weather it turns choppy or swells in great angry waves. It mirrors the mood and color of the sky.

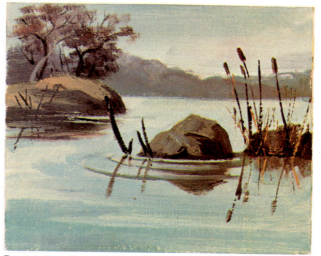

By contrast, the waters of this great mountain lake are calm and light under a peaceful blue sky.

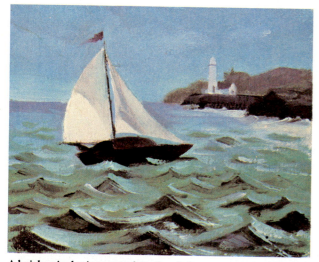

A brisk wind raises a multitude of choppy waves as sky and water darken with an oncoming squall.

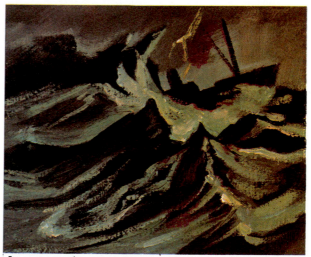

In a storm the wind-driven waves are large and high. The water reflects the darkness of the sky, the flash of lightning.

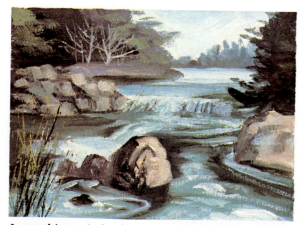

In a rushing, winding stream, water swirls around rocks, flashes as it goes over a low waterfall.

Cadmium yellow (light),
white, and cerulean blue

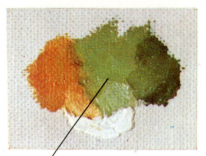

Yellow ochre, white,
and viridian

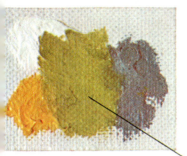

Viridian and cadmium orange.

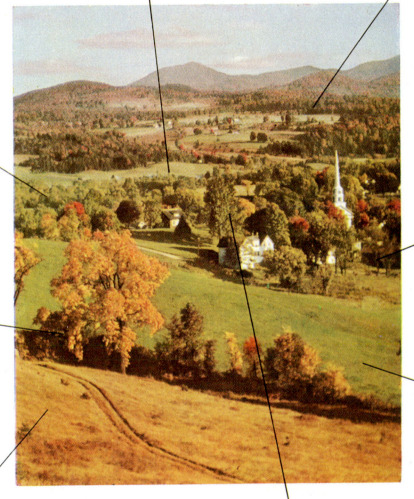

Burnt sienna and viridian

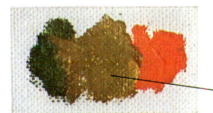

Cadmium yellow (deep),
white, and cerulean blue

Courtesy Vermont
Development
Commission

Cadmium yellow (light) and viridian

Cadmium orange and
cadmium yellow (pale)

Black and cadmium
yellow (deep)

Practice Project...colors in a landscape

This photo offers you a good opportunity to compare colors. Note the varied warm oranges and yellows up front, the greens in the middle ground, the gray-blues and violets beyond.

Do a color painting of this scene but, before starting, study it carefully. Paint it in your mind's eye first. With practice you'll be able to automatically select the colors you need for the effect you want.

The color swatches here are done with oils but you can paint the picture in watercolors. Work at any size you find convenient. (Turn the page and you'll see how a Famous Artists School Instructor painted this picture.)

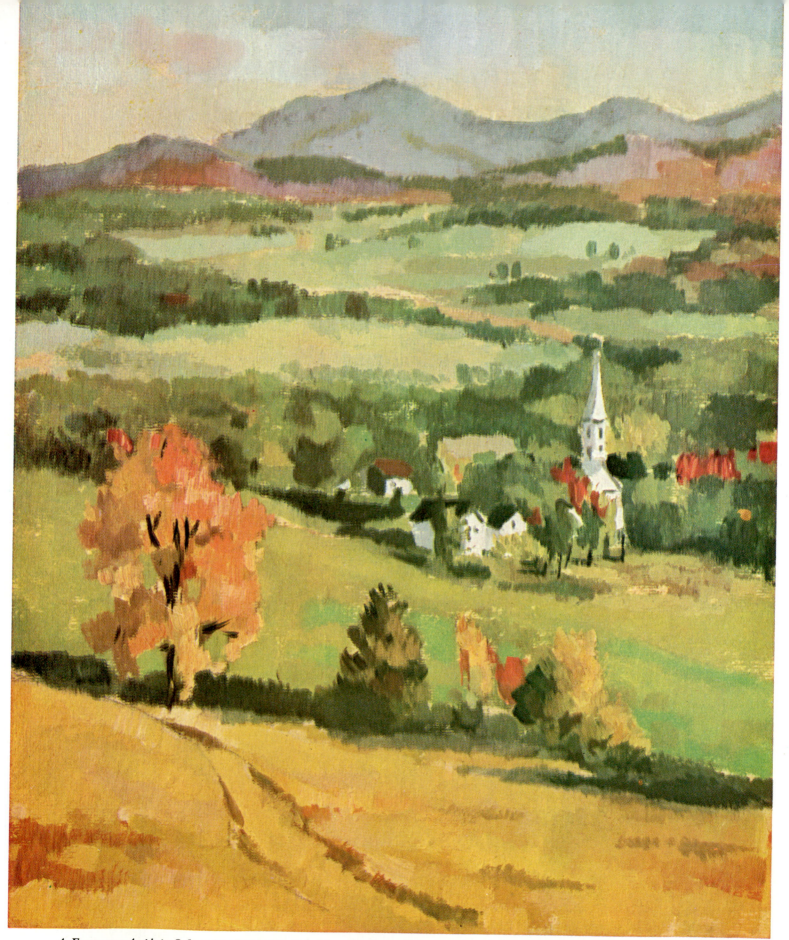

A Famous Artists School Instructor did this painting of the scene on the preceding page. Like any good painting, this picture is the artist's interpretation, not an exact copy of the photo.

Section 6

How to Paint a Landscape in Acrylics

On the following pages we show you how to paint a landscape in acrylics. This remarkable medium can produce the effects of both oil and water-color—plus others uniquely its own.

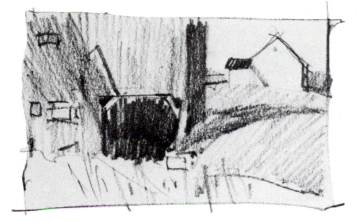

The artist made composition sketches from different points of view. He settled on this one, from close to the barn.

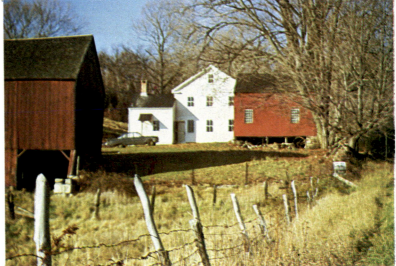

Advice on acrylic paints

Acrylic paints (also called polymer or vinyl paints) have become vastly popular, and for good reason. You can mix them with water (or acrylic polymer medium), yet they're completely waterproof when dry. You can apply them thinly, like watercolor, or you can build them up thickly, like oils, and you can use them in combination with other mediums. They dry quickly and the picture doesn't have the tendency of oil paintings to crack, chip, or yellow.

Acrylics dry so rapidly you can paint over a previous layer without disturbing it. You can produce many interesting hues and variations by applying thin transparent washes over your underpainting colors.

Commercially prepared acrylic board is available but acrylics can be applied to almost any non-oily surface. A butcher's tray makes a good palette.

You can work with watercolor or oil brushes and painting knives, but brushes need special care, since the medium dries so fast. If you set aside a brush for even a few minutes, suspend it in water. Wash brushes carefully when you finish. You can also obtain special nylon brushes with smooth hairs that resist the binding qualities of the paint and wash easily.

1 ***We sketched the scene on acrylic board, using pencil.*** Note that the barn and foreground textures dominate the composition; the house has been dropped behind a swell in the intervening land. We chose this concept because we felt the detailed textures of the foreground were the most interesting part of the subject and they lent themselves to acrylic painting. Vertical brushstrokes, made with a mixture of Hooker's green and yellow ochre, boldly wash in the barn. No attempt is made to avoid painting over the opening under the barn or the window. We've indicated the distant grass with a wash, and suggested textural effects in the foreground, using an almost dry brush with a jabbing motion.

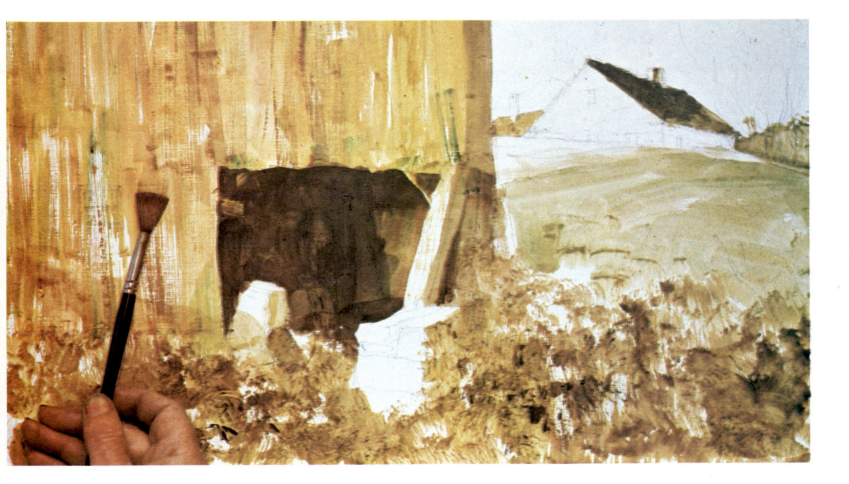

2 *Light and middle tones having been established*, the darker areas are added. Now we have the overall tonal or value pattern of our entire picture, which helps us judge how light or dark individual areas of the details should be. After stroking our brush on a piece of scrap paper to "split" the hairs, we indicate the vertical grain of the barn siding. These strokes will remain distinct even after we apply subsequent washes, because the dried acrylic paint does not blend with colors laid over it, as regular watercolors do.

Acrylic painting demonstration by *Franklin Jones* on pages 57-61 reproduced by permission of North Light Publishers from *The Pleasure of Painting* © 1975 by Fletcher Art Services, Inc.

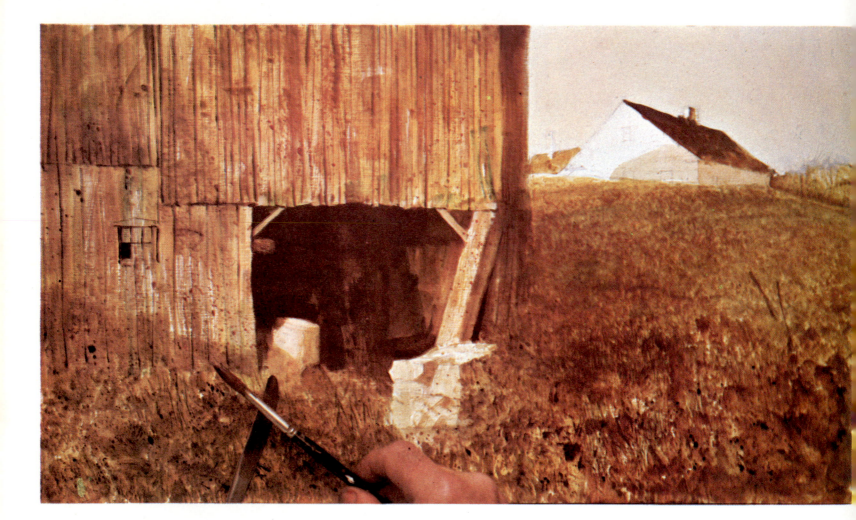

3 *Next, with the tip of the brush*, we stipple in the texture of the distant grass and develop the textures in the foreground. We used a "spatter" technique on the barn siding—tapping the loaded brush against a knife edge so as to flip little spots of color on the boards, making them look old and weathered. The sky, previously given a light blue tone, has now been treated to a pale yellow opaque wash.

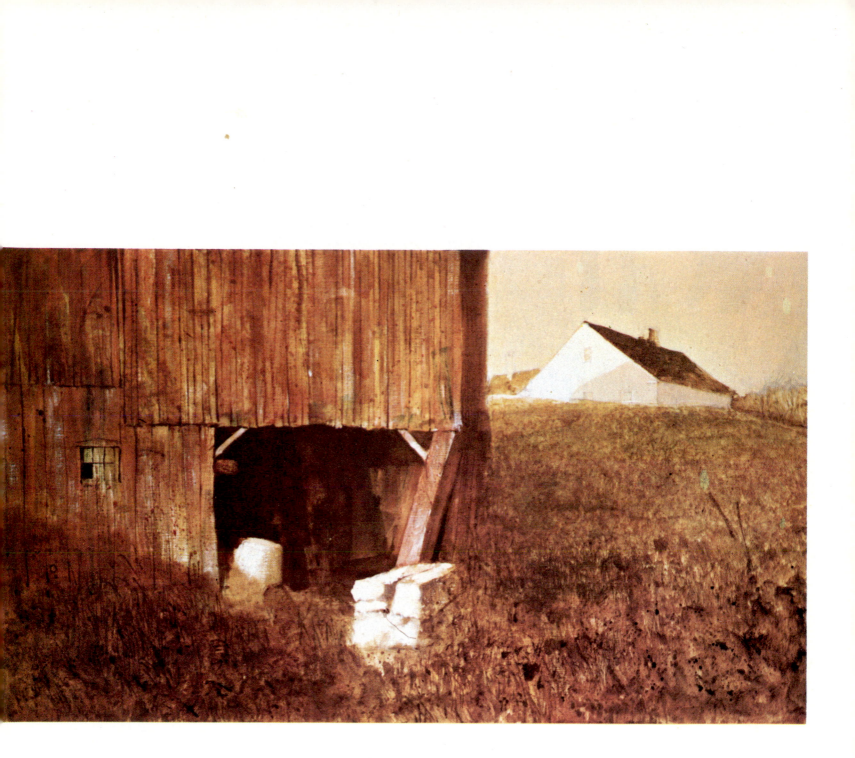

4 *Final details have been added.* Before suggesting the siding on the background house, we painted pure white on it. We also dragged thick stucco-like white over the granite blocks in the foreground, then detailed them. Note the clean fine strokes used to suggest the weeds in front. A pale yellow wash was painted over the sunlit areas without disturbing the underlying paint. This demonstration shows you only some of the effects you can easily achieve with this enjoyable medium.

Try these exciting experiments

Paint and the way it's applied adds much to the excitement of being an artist. Technique alone doesn't make art, of course, but the manner in which you apply paint can help make your pictures say what you want them to.

Make four paintings of a single landscape; paint one in each of the techniques we demonstrate here. Go out and choose a subject that

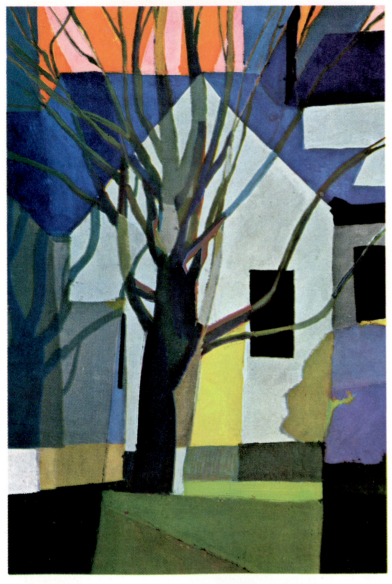

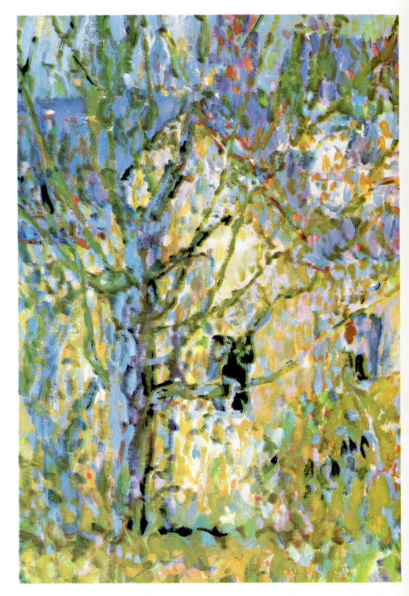

1 **Take off on your exploration** of painting approaches with a "hard-edge" picture like this one! Work for a very precise, flat design quality, catching the angles and shapes of your subject in sharp geometric planes. (Squint at your subject to see such patterns more distinctly.) Your color can be based loosely on the actual landscapes—but you can also be daring, choosing bright, intense "unnatural" colors that echo your own personal moods. Use a ruler for the straight lines if you wish.

2 **This "impressionistic" way of using paint** is fun. Sketch a rough outline, then lay in short strokes of thick paint in bright colors. Work on your entire picture area, building up your strokes to create an overall color feeling. Keep your shapes vague, the edges soft. To get the color effect you want in any section, use mostly strokes in that hue, but introduce other colors into the area. This "broken color" will create vibrancy and a feeling of unity throughout. As you work, step back about ten feet and see how your eye mixes the colors.

...*in paint handling*

really strikes your interest. Use a 10 × 14-inch picture area, either horizontally or vertically. Follow the pointers relating to the four approaches. But remember, the reason we've kept the instructions brief is that we just want to get you started. As you work, let the excitement of each new approach talk to you—be aware of what's happening on your canvas. Begin each picture with a fresh eye and an open mind!

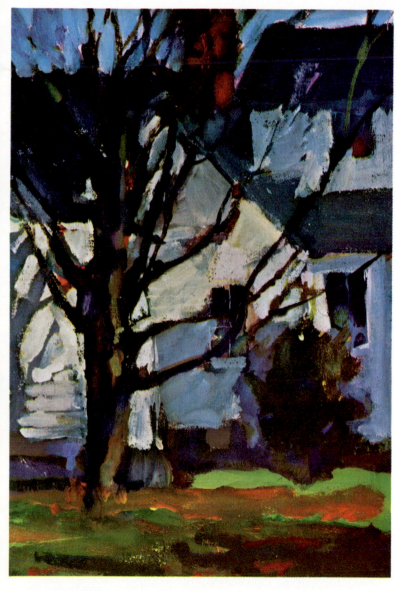

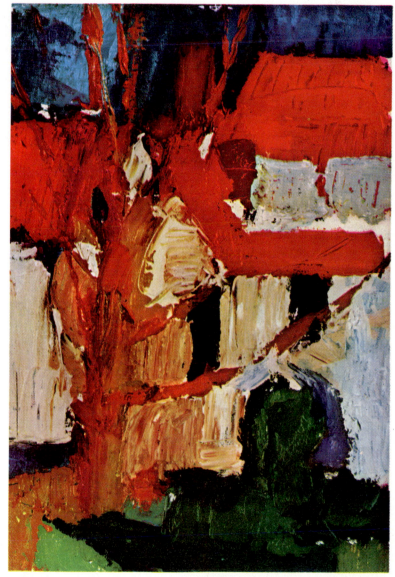

3 **The unique feature in this approach** is the effect created by the unexpected way color is applied. First paint the various areas of your canvas in very thin washes of bright color; you can be as wild as you wish, paying little attention to what shade goes where because you'll soon paint over them. Now, follow rather closely the actual colors you see. Paint freely and boldly, but leave little areas unpainted, so small patches of the rich undercolor show through. Don't overwork your painting; keep a spontaneous look. Patches of undercolor showing, lines not too sharply defined, are successful here.

4 **Put your paintbrushes aside here** and use your palette knife only! The rich, tactile look of paint put on with a knife packs a vigorous punch. Build up your picture in an abstract way, laying in your paint in thick slabs. Work for the massive shapes; don't give attention to details. Try to achieve a dynamic color effect, using vibrant hues taken as much from your imagination as from the scene before you. Let your own artistic sense be your guide.

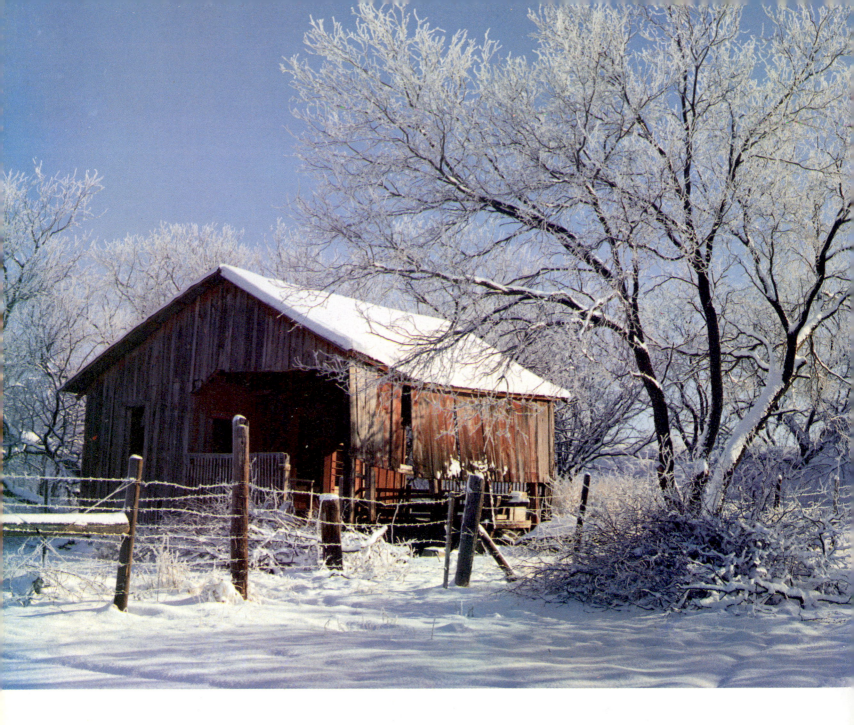

Practice Projects...*review*

This scene offers you opportunities to try out all of the different techniques and methods discussed so far. The Practice Project overlay, page 88, shows how an instructor explored the possibilities of this scene. Here are a few suggestions:

Composition. As a warm-up, do several rough composition sketches. In one, make the tree forms at the right dominate the scene, in another the fence posts and barbed wire, in a third the old barn. Don't hesitate to move elements around.

Pattern. Experiment with several black-and-white patterns similar to the sketches on page 42.

Drawing the landscape. Pretend you're actually on the scene and make a pencil landscape drawing. Base it on the most effective of your preliminary studies.

Painting the landscape. This scene would make a wonderful subject for oils, watercolors, or acrylics—or all three. Have fun!

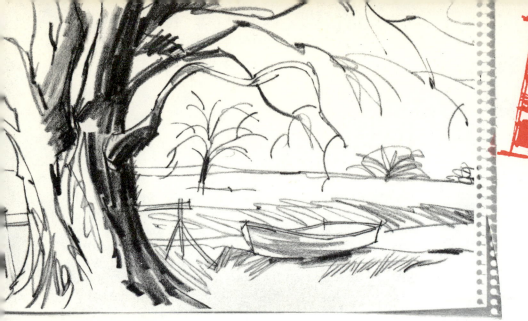

Section 7

Exploring With Eye and Sketch Pad

Landscapes, cityscapes, seascapes, skyscapes—the range of subjects to draw is wide as the world. Take a sketchbook wherever you go and draw whenever you can. The sketchbook can be of any size at all—even a pocket notebook is fine. It will be your artist's diary, written in sketches rather than words.

In the following pages we discuss different ways of looking and reacting to what you see. Experiment with all of them.

Gesture...*capturing the "spirit" of the form*

There's no better way to get acquainted with your subject, to feel out its form and spirit, than by the gesture sketch. It's a fast, scribbly kind of drawing that many artists make before they actually start to work on their pictures.

Gesture drawing is the artist's means of making visible what he senses or understands about his subject; it's his way of drawing the essential spirit of its form—what it's "doing"—rather than its literal or obvious physical aspect.

You'll have fun with gesture sketches. They're very fast and it's fascinating to see how close you can get to the essence of your subject with just a few swift strokes.

Even inanimate objects like mountains have a kind of gesture that you can feel and draw. This bold, brief sketch suggests the gesture of the Matterhorn.

Practice Project...*seeing the gesture*

This is a typical winter scene—but it's really more than that! It contains a variety of fascinating shapes. Sketch several of them separately, capturing their gestures. Then, in the frame below, combine them in an overall sketch in which the gestures contrast with one another.

On page 89 you'll see how a Famous Artists School Instructor interpreted this scene.

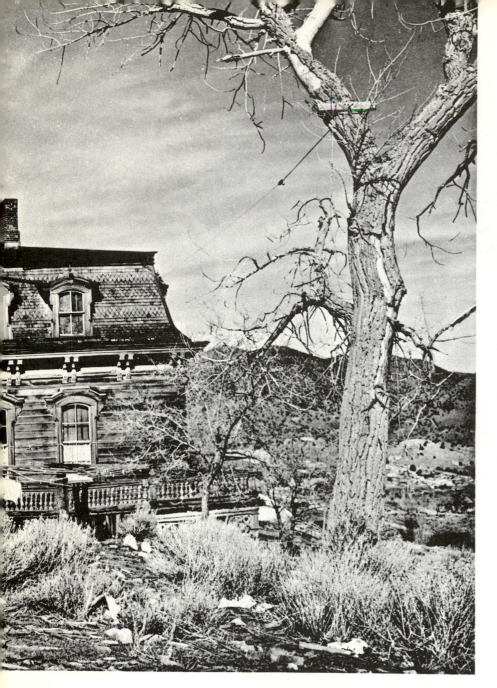

Textures Add Reality and Interest

We recognize an object not only by its form, but by the texture of its surface. For our pictures to be convincing we must create the illusion of the surface texture of things. To do this, first you have to find out the true character of the surface. Is it soft or hard? Coarse or smooth? Glossy or dull? Ask yourself questions like these and decide which characteristics best identify the object.

The next question is how to show these characteristics in your picture. What kind of strokes would best interpret the texture? Should they be long or short, straight or curved, rough or smooth?

Think how a texture feels as you draw it. Follow the direction of growth of plants and trees. Also make sure the texture contrasts with that of nearby things so the viewer can tell them apart. Careful attention to textures will add greatly to the reality and interest of your pictures.

This is not simply a tree but the texture of a tree *seen against other textures*—those of the smooth sky and the tree-dotted hill in the distance. The strokes follow the direction of growth of the tree and its branches.

The long, thin strokes follow the direction of growth of the thick clumps of brush. Note the varied direction of these strokes compared with the vertical and horizontal lines of the building.

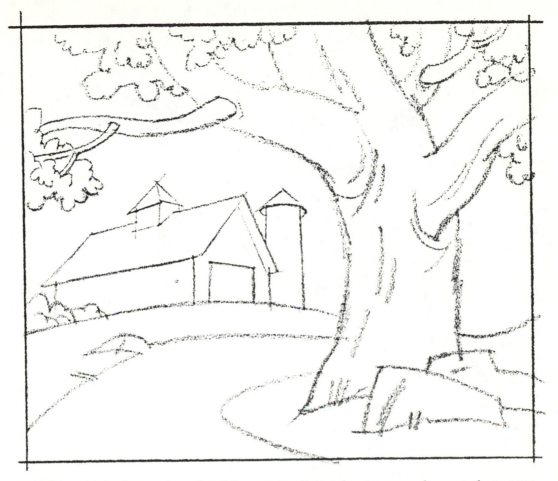

Complete this landscape picture by adding textures. Below the picture we show you the textures of some of the objects in it—grass, rocks, the tree trunk, and foliage—and how to draw them to complete an effect of realism. You may draw the textures of other things, such as the rutted and pebbly surface of the road. A soft pencil can give you all the textural effects you desire. Don't make all of your textures equally light or dark. For example, a plain white or smudged gray sky would help to bring out the dark rough bark of the tree.

When you've finished, compare what you've done with the Instructor overlay on page 90.

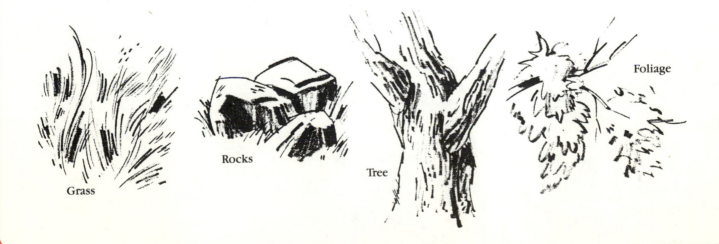

Grass

Rocks

Tree

Foliage

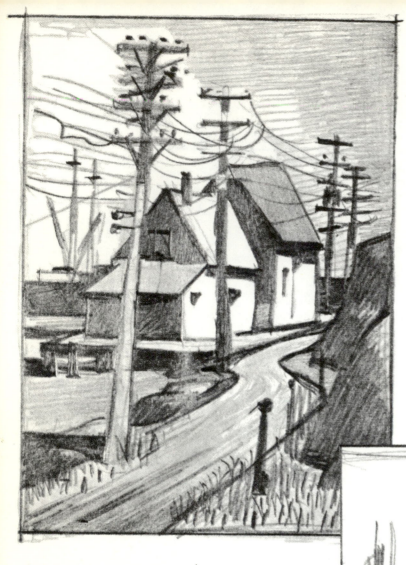

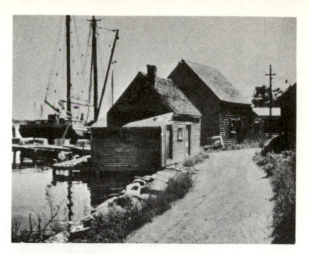

Experiments in Picture Composition

Here Dong Kingman explores a few of the compositional possibilities of the scene in the photograph. These are the kinds of studies you should make before you begin any picture.

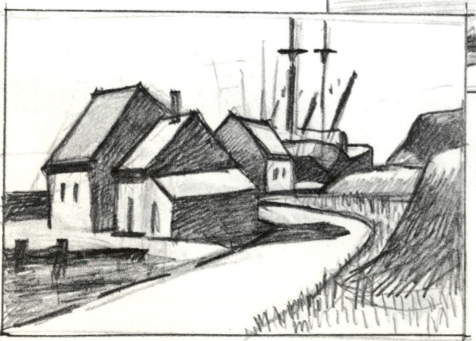

Note how Kingman has shifted some forms around and eliminated others to see what changing emphasis would do. He also tried a variety of value schemes to create different moods.

Composition is the art of arranging the various elements at the painter's disposal for the expression of his feelings. In a picture every part will be visible and will play the role conferred upon it, be it principal or secondary. All that is not useful in a picture is detrimental.
Henri Matisse

Controlling Your Compositions With Simple Shapes and Values

To plan the painting below, the artist made many small sketches to establish his major shapes and values. The sketch he finally selected is shown at right. Note that all the detail and secondary objects in the area of the building have been left out. Even the goose, so important in the final picture, isn't included in the sketch. The gate too has been absorbed into the building's shape.

Following this sketch, the artist proceeded to paint, knowing he could introduce details and secondary shapes as he wished, as long as they didn't destroy his design.

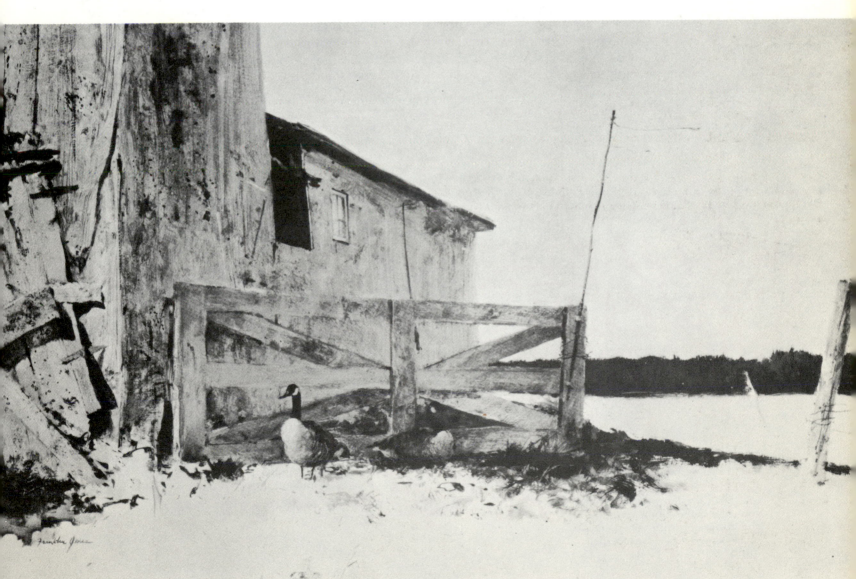

FRANKLIN JONES *On the Flyway*

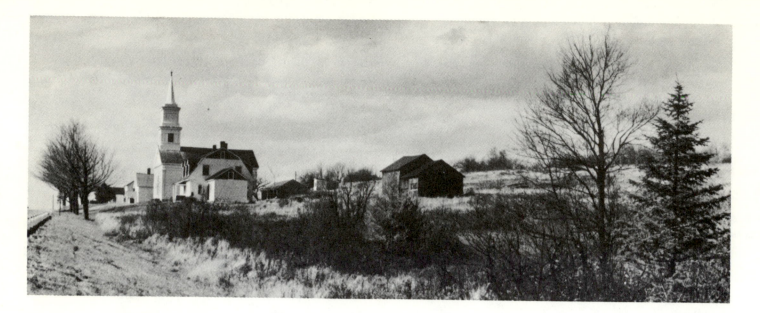

Selecting and Rearranging What You See

When you go out sketching or painting, always remember that you are an *artist*—not a *camera*. A camera records, unthinkingly, everything in front of it. By contrast, you, as an artist, can choose what you wish and create a world that's all your own. You have a perfect right to alter nature in any way you wish. You can move or change the size of buildings, trees, or even mountains! Anything goes, as long as it results in a good picture. The scene above has all the elements we need for a pleasing picture, but they cry out for artistic rearranging.

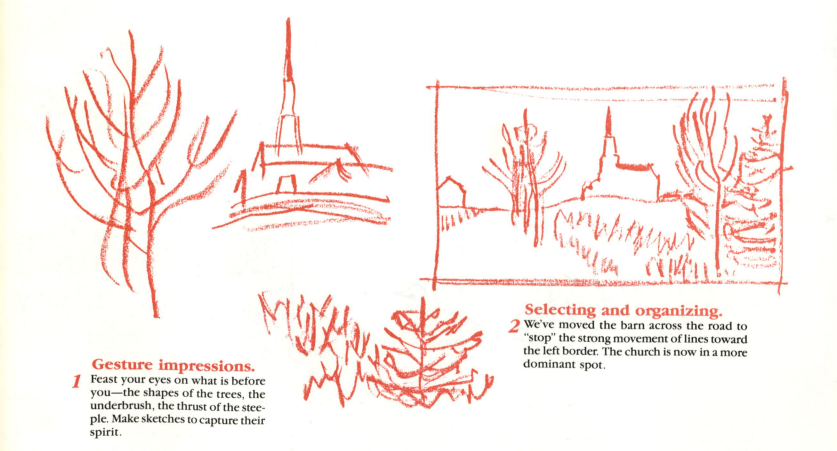

Gesture impressions.

1 Feast your eyes on what is before you—the shapes of the trees, the underbrush, the thrust of the steeple. Make sketches to capture their spirit.

Selecting and organizing.

2 We've moved the barn across the road to "stop" the strong movement of lines toward the left border. The church is now in a more dominant spot.

72

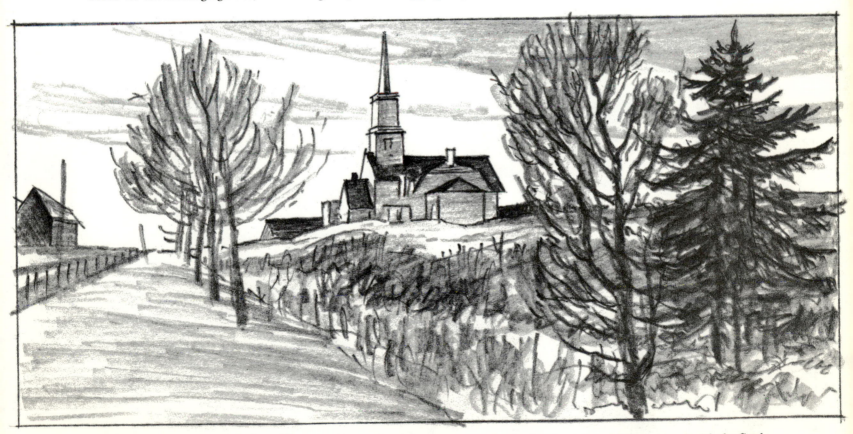

3 **Blocking in the picture.** Having settled on an effective composition, we can now develop the picture. We keep in mind the solid, basic forms, not only in the buildings, but also in the trees and the mass of the land as it swells up into the distance. We use converging lines, diminishing size, and overlapping shapes to create depth.

4 **Filling in tones and details.** Now that the elements have been organized and constructed we proceed with the final stage, developing the textures and light and dark areas. Note that the sharpest contrasts are used to draw the eye to the church—the center of interest. While adding pencil strokes we must not lose sight of our first spontaneous reaction to the unique shape and gesture of each object in the picture.

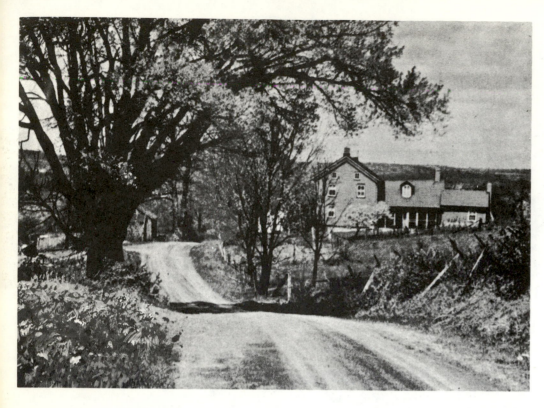

The purpose of the exercise is twofold: (1) To make you aware that you should establish simple, strong shapes in your painting before developing detail; (2) To teach you to select the value arrangement that will best show the shapes you have designed.

Some of the shapes are difficult to see. Simplify or clarify the shapes—or eliminate them if they don't contribute to the pattern of your picture. Before you start, review pages 41 through 46, and page 71.

The Instructor overlay, page 91, demonstrates several of the many ways this scene can be analyzed.

Practice Project...*finding the shapes and values*

Re-create the simplified shapes in this scene in the frame, using soft pencil.

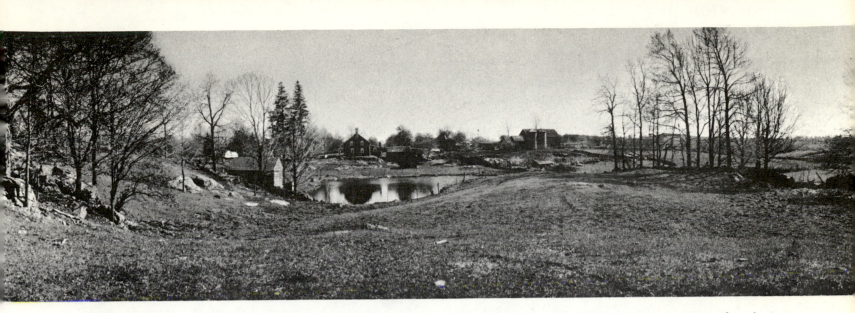

This scene, like the one on page 72, has interesting possibilities. But, as with that landscape, you are faced with the problem of selecting from a large number of elements stretching from one end of the horizon to the other. You'll have to move things around and reorganize them to make an interesting pictorial statement.

Make a pencil drawing of the scene in the frame below, using the step-by-step procedure shown on pages 72 and 73.

On the overlay, page 92, you can see how our Instructor interpreted the scene.

Practice Project...*selecting and organizing the view*

The Weather in Your Landscape

What do different kinds of weather look like? Before you can portray the warmth of sunshine, the ghostly feeling of fog, the drama of an impending storm, or the quiet mood of dusk you must know what each of these is really like in *visual terms.*

Your own firsthand observation counts most in learning to paint weather. You don't have to travel far to observe it—it's all around you. Study the weather as if you were ready to paint it—note the shapes, values, and edges of objects and how different they appear under different conditions. The examples below point out some of these changing effects. Compare these examples carefully, and learn all you can from them. Weather is important—there will be some in every landscape you paint.

In a sunny scene the planes which face the overhead sun are bright and sharp. The shadows are definite but filled with light thrown back into them from sunlit surfaces. The whole scene is high in key (light in value).

When fog envelops the landscape, soft, diffused edges predominate. The tones of all but the nearest objects are close together in a very high key. In painting this effect of fog it is important to put in no more than you see.

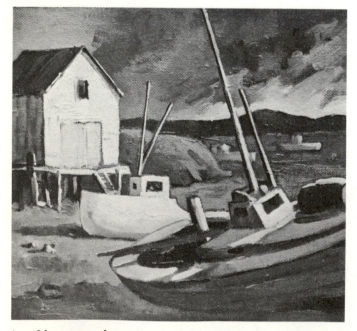

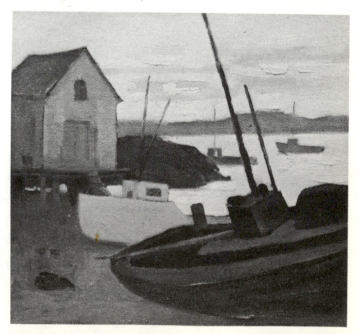

A sudden storm that moves in during a sunny day has its own dramatic pattern. The sunstruck objects stand out in sharp contrast to the dark sky and the distant shore and water that are under the shadow of the clouds.

At twilight the values of objects both near and far begin to merge, and the sharp contrasts of daylight are gone. The forms tend to appear flatter in this light and to silhouette against sky and water.

Moving away from realism– *inventing shapes and textures*

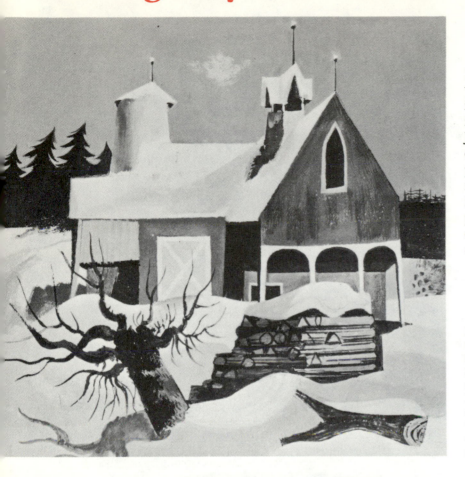

The inspiration for the forms and textures in your landscapes springs from what you observe in nature—but in no way are you limited to copying what you see, or to interpreting it realistically. Just as you can move forms around or leave them out when you plan a composition, you can interpret the forms and textures of your subject imaginatively, changing them freely to create interesting and unusual designs. The two pictures on this page make the point. Feel free to express yourself creatively in your landscapes. Nature, after all, is only the starting point. It is you who are the artist.

In the top picture the artist has rendered his forms and textures fairly realistically, but he has also stylized them in an individual and rather humorous way. The emphasis here is on realistic textures and forms. The smooth, quiet surfaces of the snow, barn, and sky are put down quite literally. The twisted tree and its realistic shadow contrast strongly with these smoother textures. We clearly see the texture of the tree and logs in the foreground, while the distant trees are put in as flat tones—only their ragged edges suggest their texture.

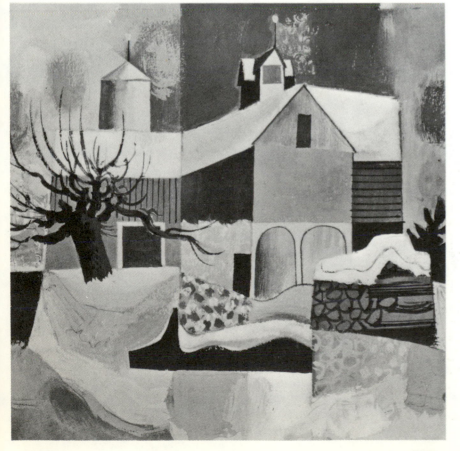

In the bottom picture the artist has departed much further from the subject; breaking up the sky into different planes and changing forms and textures with considerable liberty. The result is a somewhat abstract and highly personal design. Arbitrary, invented textures add interest and excitement to every area of this somewhat abstract treatment of the landscape. Paint is laid on thickly with a knife on some parts of the varied foreground; on other areas it has been brushed on thinly. In the sky, light and dark tones are spread over the background. Shapes and textures seem arbitrary but the basic characteristics of objects aren't lost.

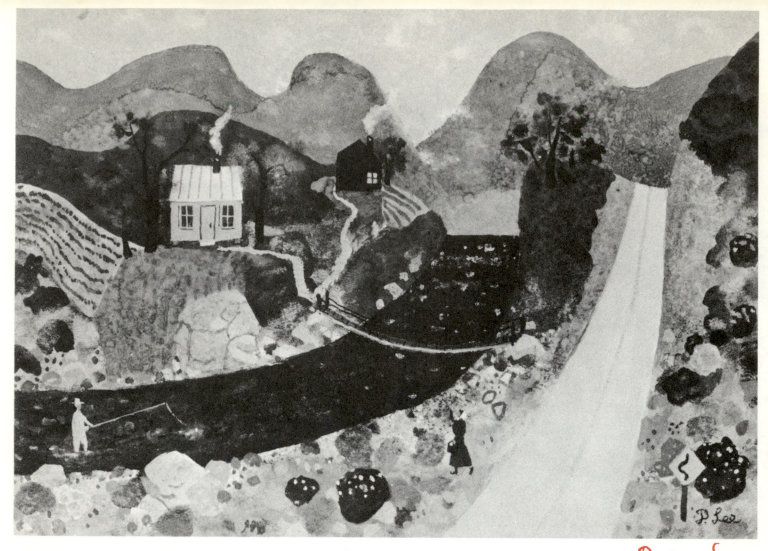

Decorative Landscape ... *a very personal approach*

Doris Lee

Here we see a picture by Doris Lee, a celebrated American painter. Her style is far from literal, with textures used in a highly personal way, creating a picture that looks like a tapestry. Stylized as these textures are, however, we have no difficulty in recognizing the sky, road, bushes, and other objects here. Notice the attractive overall design.

Overall design. The artist arranged forms and textures to create an attractive design. Note the varied arrangement of the bushes on either side of the road, the simple stream, the pattern of lines in the plowed fields. The hills are stylized, and Lee has set light against dark and dark against light for an interesting effect.

Awareness of form. Although there are many textures here and the design made by them dominates the picture, they still suggest the form underneath.

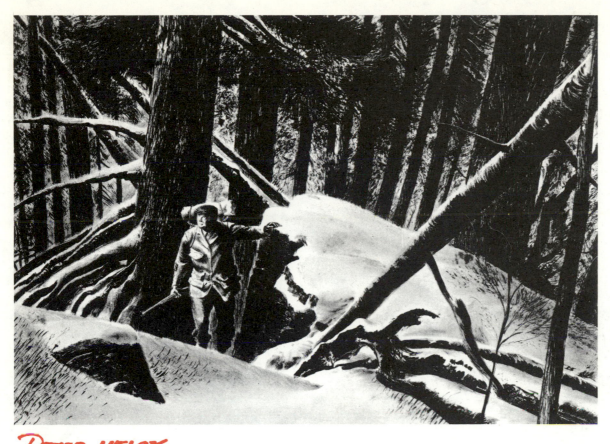

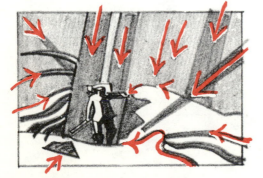

Although the hunter is a small figure, we have no difficulty in seeing him amidst the huge trees. This is because Helck used the lines of the trees and the landscape to guide our eye to the man.

Relating Figures to a Landscape

In some of your landscapes you will want to show a figure or figures. As a rule these will be fairly small, or the picture will be more a figure painting or storytelling picture than a landscape. Inconspicuous though the figure may be, you still may wish to give it emphasis, so the viewer won't overlook it in the landscape.

Careful composition can enable you to lead the viewer's eye to the figure either directly or indirectly. In the picture above by Peter Helck, the figure of the hunter is a small part of the total composition. Because the hunter was as much his subject as the woodland, Helck wanted to direct our attention to him instantly. He arranged his landscape elements so all the major lines of the picture either point to the figure or build a frame around it.

Note how Doris Lee achieved a similar effect in the painting on the facing page. The broad sweep of the stream quickly leads the eye to the fisherman, whose light form stands out against the dark of the water. The almost parallel white road directs our attention to the contrasting dark figure of the woman coming toward him. Both figures, moreover, are placed in the foreground. Still they are kept inconspicuous because it is the overall landscape, not the people, that is the artist's subject.

Think with Tracing Paper

The beauty of using tracing paper is that it allows you to first make a preliminary trial drawing; then, because it's transparent, you can slip it under a clean sheet and proceed to correct and adjust as you redo the drawing.

You can repeat this as many times as it takes. Be sure, however, that you *don't just mindlessly trace.* Make each successive drawing an improvement, and strive for spontaneity in every new version.

1 *New sheet:* Fasten a sheet of tracing paper over your sketch and do a new drawing, using your previous one as a guide and making the necessary improvements.

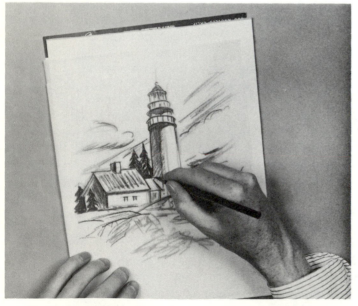

2 *Refining your drawing:* If your drawing needs further adjustments, place a clean sheet of tracing paper over it and continue developing it to the degree of finish you wish.

Transfer with Tracing Paper

It's easy to transfer the outlines of a drawing onto another surface. First, lay a sheet of tracing paper over the picture you wish to duplicate and, with a medium soft pencil, trace the main outlines. Then follow the steps below. If your original drawing was done on tracing paper, as described to the left, just turn it over, blacken the back of the outlines, and trace it down. This method gives you a clean surface on which to work, free from erasures and smears.

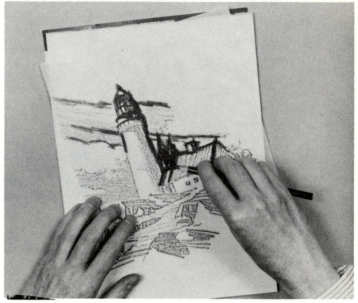

1 *Preparing the back:* Turn your tracing over and blacken the paper right over the back of your traced lines with a soft pencil.

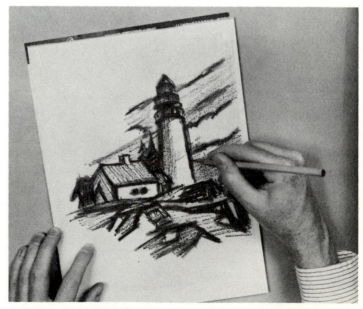

2 *Transferring:* Tape the top corners of your tracing onto the surface on which you plan to draw or paint. With a sharp pencil trace over the outlines and they will be transferred to your drawing surface.

Section 10

Tracing papers...*the following pages include these items:*

3 Outline Guides for Practice Projects. You can transfer these onto surfaces appropriate for painting using the transfer method described on page 80.

9 Instructor Overlays. These demonstrations show how Instructors at Famous Artists School completed the Practice Projects. Remove them to compare with your own project drawings.

4 Blank sheets of tracing paper. These will give you a chance to try out this useful and popular type of paper. Similar paper is readily available at stores selling art supplies.

FREE ART LESSON. This is the most important project of all. You'll find it at the end of the book. Complete it and mail it to get a free evaluation from the instruction staff of Famous Artists School.

Note: Slip a sheet of white paper under this page for easy reading.

<div style="writing-mode: vertical-lr">TEAR OUT PAGE ALONG THE PERFORATION</div>

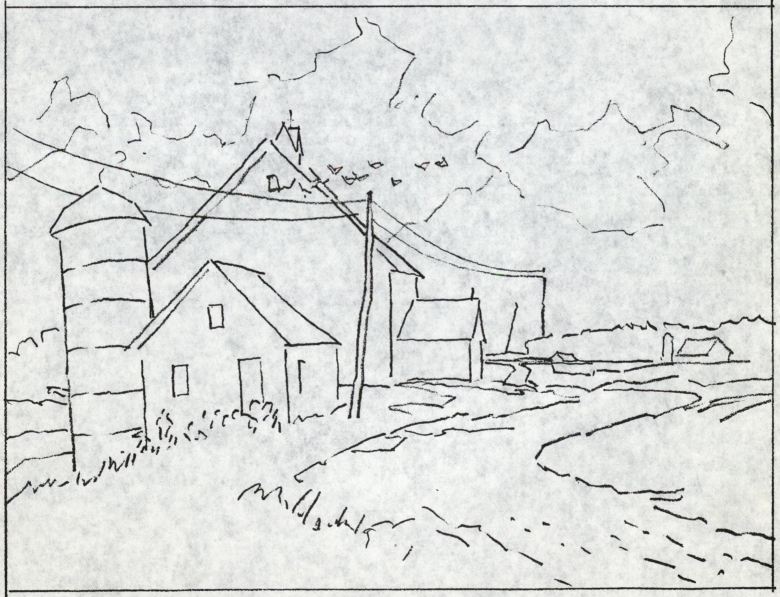

Outline Guide...*country road.* For Practice Project on page 25.

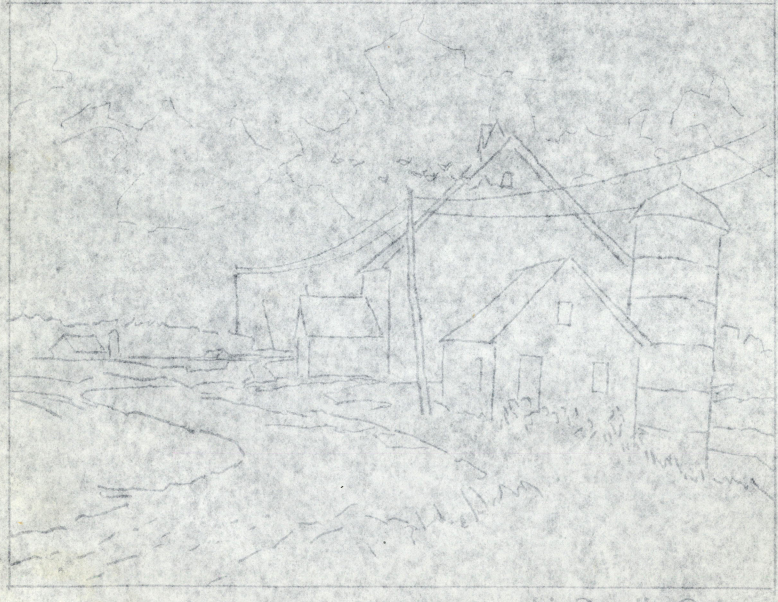

Outline Guide...country road. For Practice Project on page 25.

Instructor Overlay...*country road.*

For Practice Project on page 25.

Soft, graded edges of shadow show rounded form of silo. Also, note curved edge of shadow.

Sharp edge between shadow and light side of building shows cube-like form.

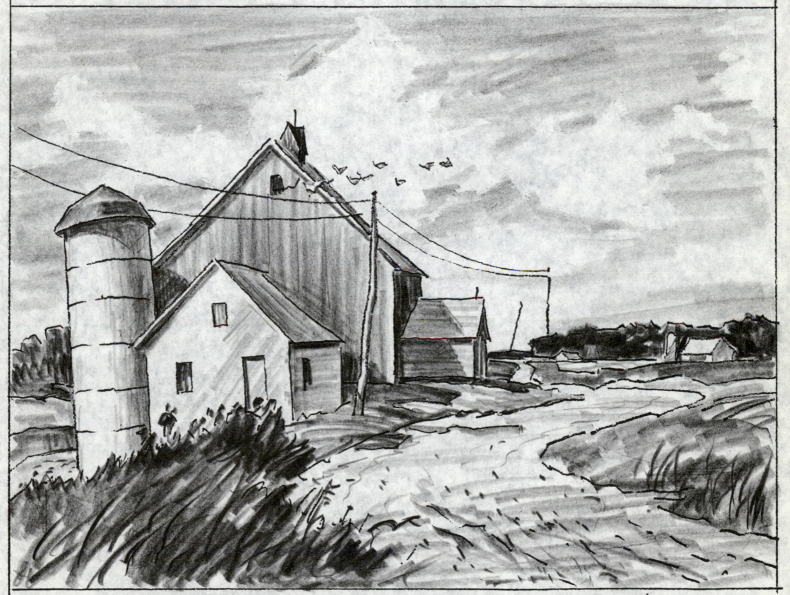

Sweeping pencil strokes show grass... flat strokes show ground.

Note how texture of road is indicated with irregular lines and stippled dots.

Slip a sheet of white paper under this overlay for easy viewing. You can also remove it and place it over your Practice Project for comparison and helpful suggestions from an Instructor of the Famous Artists School.

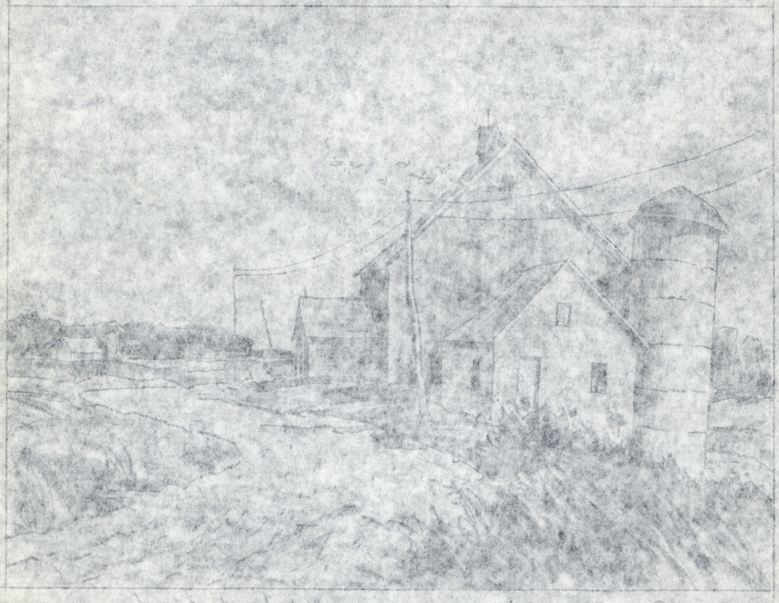

Slip a sheet of whitepaper under this overlay for easy viewing. You can also remove it and place it over your Practice Project for comparison and helpful suggestions from an instructor of the Famous Artists School.

Outline Guide...*barn and silo.*
For Practice Project on page 33.

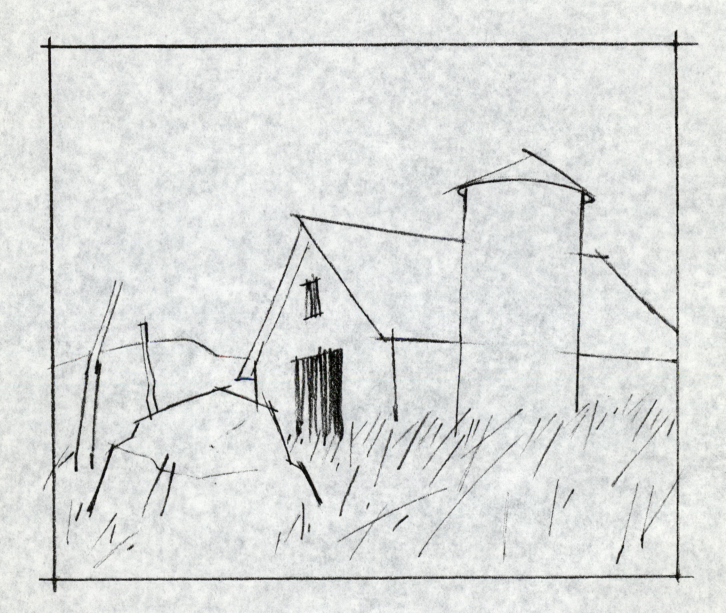

TRACE ON BACK ALONG THE PERFORATION

Instructor Overlay...*barn and silo.*

For Practice Project on page 33.

Light, feathery lines in sky contrast with dark, bold strokes depicting solid forms.

Study curved shadow edges on round silo.

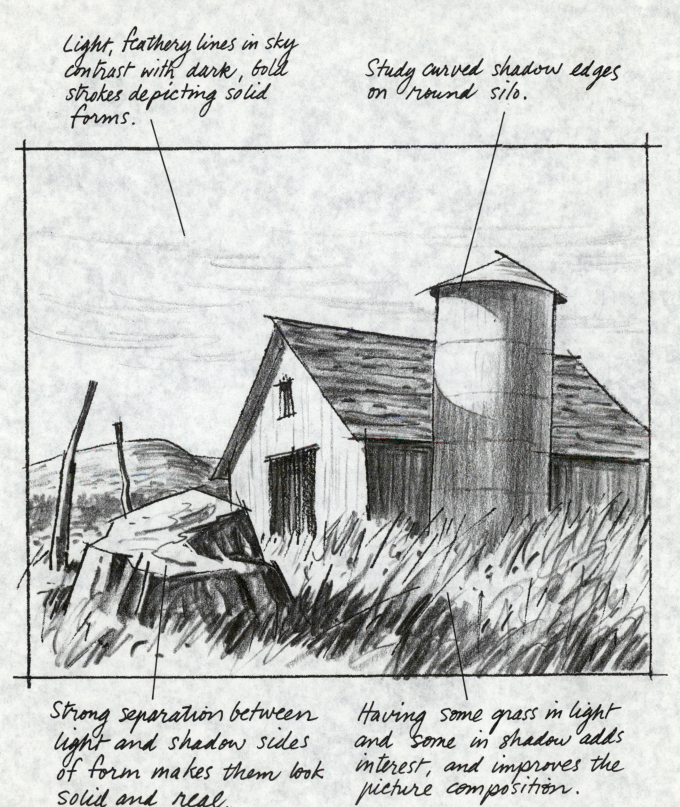

Strong separation between light and shadow sides of form makes them look solid and real.

Having some grass in light and some in shadow adds interest, and improves the picture composition.

Slip a sheet of white paper under this overlay for easy viewing. You can also remove it and place it over your Practice Project for comparison and helpful suggestions from an Instructor of the Famous Artists School.

TEAR OUT PAGE ALONG THE PERFORATION

Outline Guide . . . tree. For Practice Project on page 10.

85

Instructor Overlay... *designing patterns.*

For Practice Project on page 43.

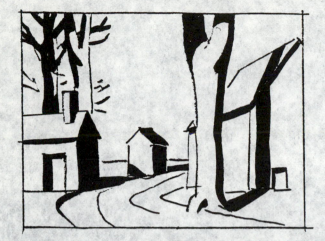 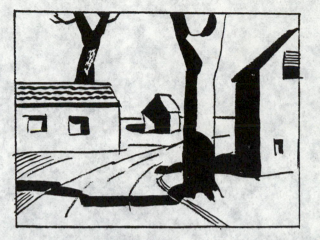

In these two designs we have used only small areas of black. This gives us a bright sunny look ... evoking a happy, light-hearted mood.

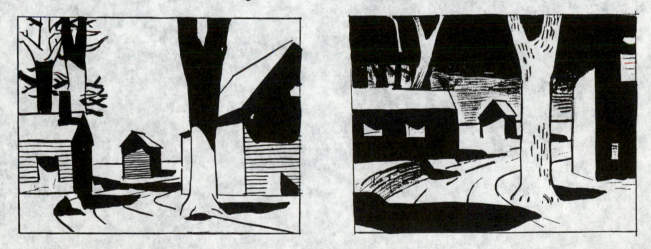

As we add more blacks, a heavy mood of mystery or gloom is suggested. These are but a few of the hundreds of variations that could be explored by shifting the black and white design shapes.

Slip a sheet of white paper under this overlay for easy viewing. You can remove it for comparison with your Practice Project. You'll find these suggestions from an Instructor of the Famous Artists School most helpful.

In these two designs we have used only small
areas of black. This gives us a bright, gay
look ... evoking a happy, light-hearted mood.

As we add more blacks, a heavy mood of mystery
or gloom is suggested. These are but a few of
the hundreds of value tones that could be
explored by shifting the black and white
design shapes.

Slip a sheet of white paper under this overlay for easy viewing. You can remove it for
comparison with your Practice Project. You'll find these suggestions from an Instructor
of the Famous Artists School most helpful.

Instructor Overlay...*value patterns.*
For Practice Project on page 46.

HERE ARE SOME OF THE MANY PATTERNS WE CAN CREATE WITH SIMPLE FLAT SHAPES OF BLACK, WHITE AND GRAY, ELIMINATING DETAILS.

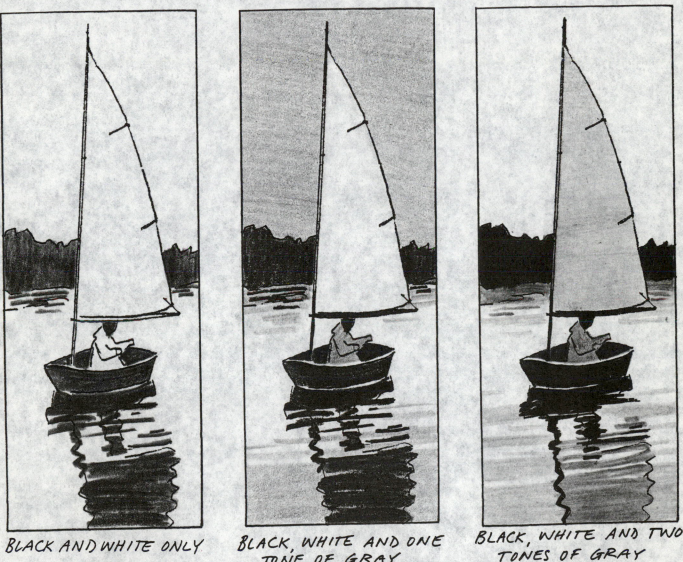

BLACK AND WHITE ONLY

BLACK, WHITE AND ONE TONE OF GRAY

BLACK, WHITE AND TWO TONES OF GRAY

First, note how strong a simple, basic pattern of black and white can be.

By adding one gray tone we achieve more realism, and suggest a mood.

Now we use two tones of gray... but we still retain the basic pattern.

Slip a sheet of white paper under this overlay for easy viewing. You can remove it for comparison with your Practice Project. You'll find these suggestions from an Instructor of the Famous Artists School most helpful.

HERE ARE SOME OF THE MANY PATTERNS WE CAN CREATE WITH SIMPLE FLAT SHAPES OF BLACK, WHITE AND GRAY, ELIMINATING DETAILS.

BLACK, WHITE AND TWO TONES OF GRAY

BLACK, WHITE AND ONE TONE OF GRAY

BLACK AND WHITE ONLY

Now we like two tones ... but we still have the basic pattern.

By adding one more tone we achieve more realism, and suggest a mood.

First, note how strong a simple basic pattern of black and white can be.

Slip a sheet of white paper under this overlay for easy viewing. You can remove it for comparison with your Practice Project. You'll find these suggestions from an instructor of the Famous Artists School most helpful.

87

Instructor Overlay...*review.*

For Practice Project on page 64.

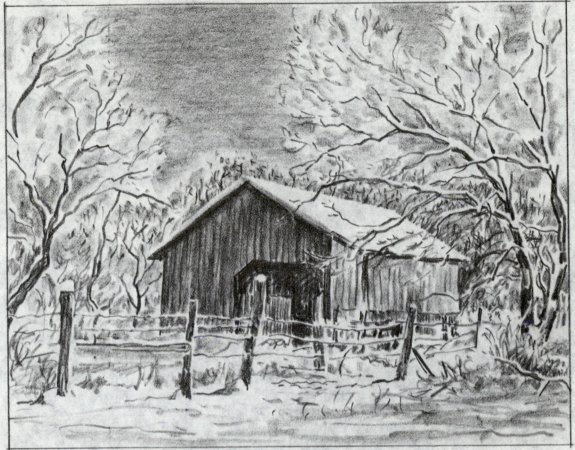

Compare this sketch with the photograph on page 64 and you'll see some interesting changes we've made.. to make a stronger composition and direct the "eye path" of the viewer.

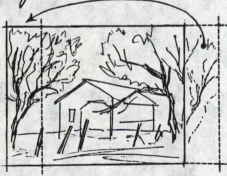

Since the left portion of the picture was weak, we "sliced off" a section from the right side and moved it to strengthen the left!

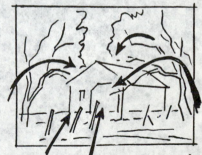

Now see how the redesigned tree and fence posts lead the eye to the door of the barn, and how the left side of the picture is stronger.

Slip a sheet of white paper under this overlay for easy viewing. You can remove it for comparison with your Practice Project. You'll find these suggestions from an Instructor of the Famous Artists School most helpful.

Compare this sketch with the photograph on page 64 and you'll see some interesting changes we've made. To make a stronger composition, we had added—the length of the trees.

See the left portion of the picture. This made the "slant off" a section. Now the right side and moved it to spread out the light.

Now see how the picture—trees and fence posts tilt. We are in the door of the road, and here the left. Side of the picture is stronger.

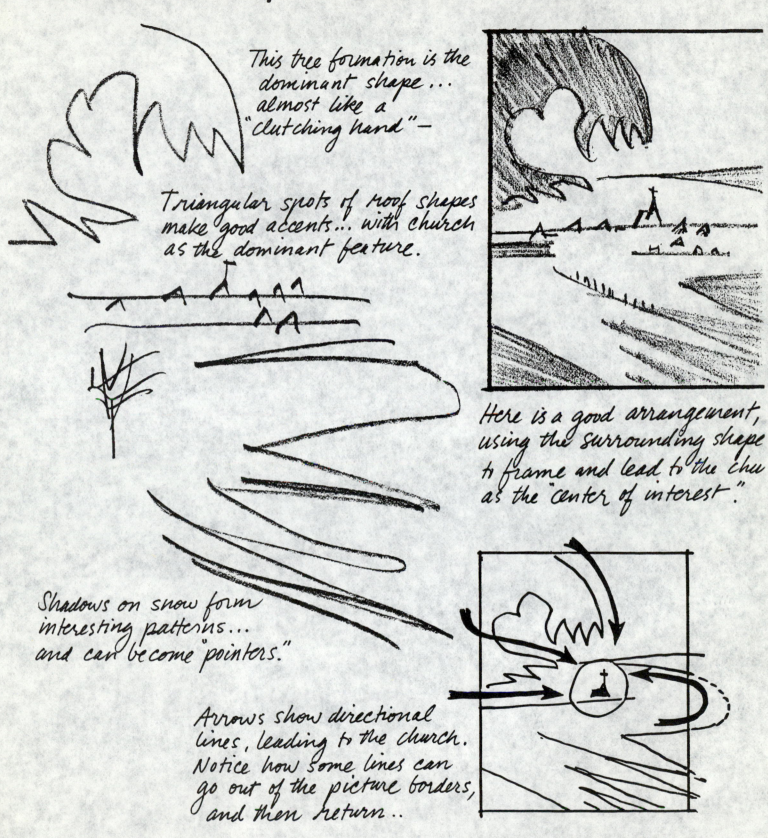

This tree formation is the dominant shape… almost like a "clutching hand" —

Triangular spots of roof shapes make good accents… with church as the dominant feature.

Here is a good arrangement, using the surrounding shape to frame and lead to the chu as the "center of interest."

Shadows on snow form interesting patterns… and can become "pointers."

Arrows show directional lines, leading to the church. Notice how some lines can go out of the picture borders, and then return..

Slip a sheet of white paper under this overlay for easy viewing. You can remove it for comparison with your Practice Project. You'll find these suggestions from an Instructor of the Famous Artists School most helpful.

TEAR OUT PAGE ALONG THE PERFORATION

This tree formation is the
dominant shape . . .
almost like a
"clutching hand."

Triangular spots of roof shapes
make good accents . . . with cluster
as the dominant feature.

Here is a good arrangement,
using this Subordinating shape.
It frames and lead to our
as the "Center of interest."

Shadows on snow form
interesting patterns . . .
and can become "pointers."

Arrows show directional
lines, leading to the church.
Notice how some lines even
go out of the picture borders,
and then return . . .

Slip a sheet of white paper under this overlay for easy viewing. You can remove it for
comparison with your Practice Project. You'll find these suggestions from an instructor
of the Famous Artists School most helpful.

Instructor Overlay...*creating textures.*
For Practice Project on page 69.

For Practice Project on page 69.

Don't overdo the textures on flat surfaces.

Light lines suggest clouds.

Heavy stroke suggest bar and rocks

Sharp edge where shadow falls on silo. Curve shows round form.

HERE ARE SOME TIPS TO HELP MAKE YOUR FORMS LOOK SOLID AND REAL.

Shadow is darkest next to light side of barn.

Reflected light here

Keep in mind the cylindrical forms that make up the tree.

Slip a sheet of white paper under this overlay for easy viewing. You can also remove it and place it over your Practice Project for comparison and helpful suggestions from an Instructor of the Famous Artists School.

90

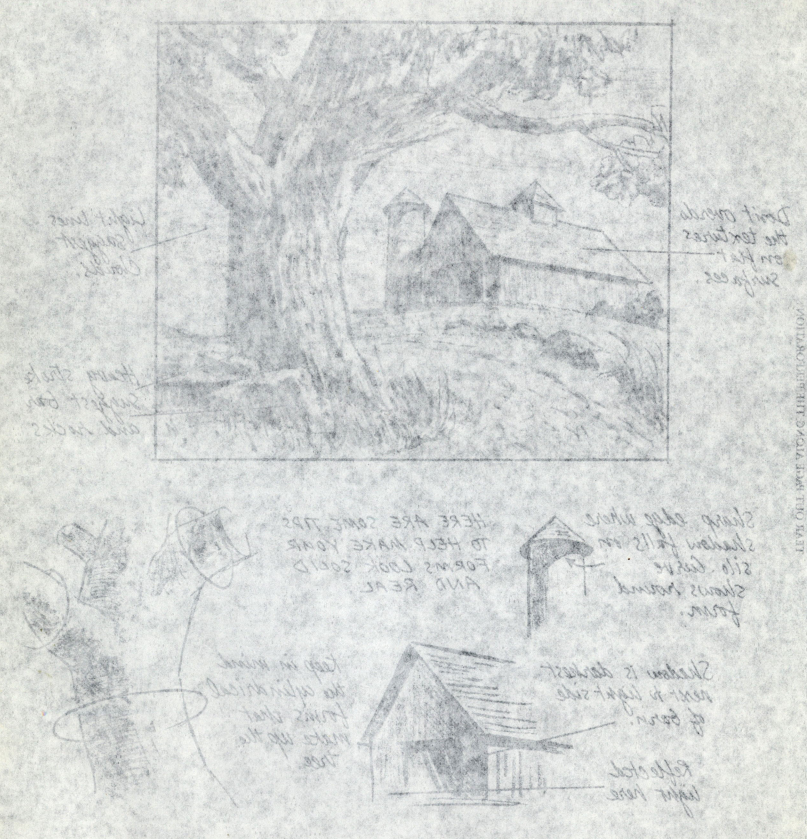

Slip a sheet of white paper under this overlay for easy viewing. You can also remove it and place it over your Practice Project for comparison and helpful suggestions from an Instructor of the Famous Artists School.

90

Instructor Overlay...*finding the shapes and values.*

For Practice Project on page 74.

THERE ARE MANY WAYS TO DESIGN THESE SHAPES. HERE ARE A FEW.

Here are two ways to handle the center group of trees.
 1. Consider it as a separate value from the surroundings. (tree trunks are optional)
 2. Combine the foreground foliage and group of trees as a single shape and value.

Here three values are used to describe the house. Windows and other details are not important.

Actually, a single shape and value is sufficient to say HOUSE.

The shadow across the road is so strong in the photo that you could consider it part of the major pattern... or you can eliminate it so we see the road as a single shape.

Slip a sheet of white paper under this overlay for easy viewing. You can remove it for comparison with your Practice Project. You'll find these suggestions from an Instructor of the Famous Artists School most helpful.

91

THERE ARE MANY WAYS TO DESIGN THESE SHAPES. HERE ARE A FEW.

Here are two ways to handle the smaller group of trees:
1. Consider them as a separate value from the surrounding area. (Tree trunks also entered.)
2. Combine the foreground foliage and group of trees as a single shape and value.

Here three values are used to describe the house, windows and other details that are important.

Actually, a single shape and value is sufficient for the house.

The shadow across the road is also shown in the photo that you could remember to paint if the major patterns were so abstracted it so as to see the road as a single shape.

Slip a sheet of white paper under this overlay for easy viewing. You can remove it for comparison with your Practice Project. You'll find these suggestions from an instructor of the Famous Artists School most helpful.

91

Instructor Overlay...*selecting and organizing the view.*

For Practice Project on page 75.

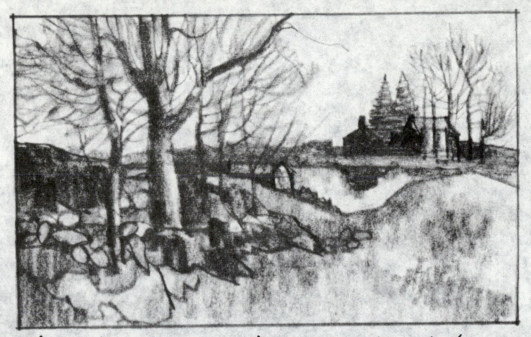

We've extracted the most interesting elements that were scattered throughout the scene on page 75, and arranged them into a well-organized picture design.

TEAR OUT PAGE ALONG THE PERFORATION

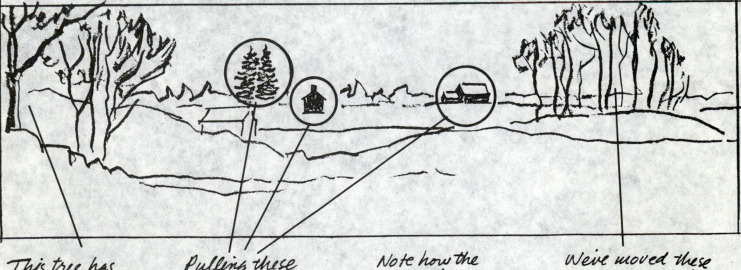

This tree has most interesting shapes - let's feature it.

Pulling these elements together gives a strong background unit.

Note how the composition is "tightened" to avoid monotonous empty space

We've moved these trees across the lake and strengthened foreground shapes

Slip a sheet of white paper under this overlay for easy viewing. You can remove it for comparison with your Practice Project. You'll find these suggestions from an Instructor of the Famous Artists School most helpful.

Note: I've circled the most interesting elements that were scattered throughout the scene on page 75, and arranged them into a well-organized picture design.

Note: weeded-out trees gives the eye a smooth, uncluttered sweep.

Note how the composition is organized to draw your eye into the picture with avoid monotonous empty space.

Pulling these elements together gives a strong center of interest.

This tree has most interesting shapes — left looking at it.

Slip a sheet of white paper under this overlay for easy viewing. You can remove it for comparison with your Practice Project. You'll find these suggestions from an instructor of the famous artists school most helpful.

92

Tracing Paper. These sheets will give you a chance to try out this useful and popular type of paper. Similar paper is readily available at stores selling art supplies.

Tracing Paper. These sheets will give you a chance to try out this useful and popular type of paper. Similar paper is readily available at stores selling art supplies.

Tracing Paper. These sheets will give you a chance to try out this useful and popular type of paper. Similar paper is readily available at stores selling art supplies.

Tracing Paper. These sheets will give you a chance to try out this useful and popular type of paper. Similar paper is readily available at stores selling art supplies.

Tracing Paper. These sheets will give you a chance to try out this useful and popular type of paper. Similar paper is readily available at stores selling art supplies.